Infrared Portrait
TECHNIQUES
AND IMAGES IN
BLACK & WHITE **Photography**

Richard Beitzel

AMHERST MEDIA, INC. ■ BUFFALO, NY

Published by:
Amherst Media, Inc.
P.O. Box 586
Buffalo, N.Y. 14226
Fax: 716-874-4508
www.AmherstMediaInc.com

Publisher: Craig Alesse
Senior Editor/Project Manager: Michelle Perkins
Assistant Editor: Paul E. Grant

ISBN: 1-58428-012-3
Library of Congress Card Catalog Number: 99-76615

Printed in the United States of America.
10 9 8 7 6 5 4 3 2 1

Acknowledgements:
I want to thank my editor, Paul Grant, for sorting through all of my jumbled thoughts and putting them down in an organized fashion. I thank all of my clients and fellow photographers who have helped to make me the artist I am today. To my wife, Esther, thanks so much for all of your support over the years and your proofreading abilities. To God, thank you for showing me talents I never knew I had.

Table of Contents

Technical Aspects of Infrared

☐ Getting Started

Before you run out and shoot your first roll of infrared film, there are important technical considerations which must be kept in mind to produce successful images.

☐ Invisible Light

Fundamentally, you must learn to think of light in a new way. What we commonly think of as "light" is actually only a small percentage of the electromagnetic spectrum. At one end of this scale are powerful waves (such as gamma- and x-rays), at the other are radio and microwaves. In between the two is the small portion of the spectrum that can be observed by the human eye. Infrared film is able to "see" beyond the capabilities of our eyes and pick up the longer waves that are called "infrared."

☐ Film Sensitivity

Infrared waves are themselves divided into two sub-categories – near and far. Far infrared is what we feel as heat from the sun. This is not, however, the infrared that infrared films record. Instead, infrared film records near infrared waves, those that lie closer to (but not within) the visible spectrum. Infrared film is also very sensitive to ultraviolet and blue wavelengths (in fact, it is even more sensitive to these waves than to infrared). In normal daylight conditions, this sensitivity would render an infrared image indistinguishable from an normal black & white image. It is for this reason that filtration (normally with a yellow, orange, red or opaque filter) is required to give infrared images their characteristic look. These filters serve to block the visible light, allowing the infrared waves to accomplish the exposure.

"Infrared film is also very sensitive to ultraviolet and blue wavelengths..."

☐ Angles of Refraction

Another important technical consideration which must be taken into account is the fact that infrared rays do not focus on the same point as visible light rays. Imagine a prism. This piece of glass is cut such that light waves passing through it refract (bend) as they pass through it. How much a particular type of light will bend depends on its wavelength. The differences in angle of refraction are what create a "rainbow" effect as the light exits the prism. Each different color of light (each

defined by its unique wavelength) bends at a different angle, separating the lighting into red, orange, yellow, green, blue, indigo and violet in the visible spectrum. Invisible light (such as infrared waves) also bends at its own unique angle.

☐ Focusing Techniques

In a camera, lenses are ground and coated to compensate for refraction and ensure that all the wavelengths of the visible spectrum focus precisely on the same plane (the film plane). Unfortunately, this correction does nothing to focus invisible light waves. Fortunately, a simple adjustment of the focusing ring can compensate for the different angle of refraction and ensure that the infrared light will focus on the film plane. To make this correction, you will be best off focusing in a manual mode. (If your camera is auto-focus only, consult your manual for instructions on focusing for infrared.) Since infrared light rays are longer than visible light rays, when an image is focused for visible light, the infrared light focal plane will lay slightly behind the film plane.

Typically, lenses have a separate focus mark imprinted upon them for infrared. Zoom lenses generally have an infrared focusing line on the lens barrel. To focus your infrared image, first focus normally through the viewfinder, then rotate the focus ring until the focal distance lines up with the infrared marking instead of the standard mark.

☐ Further Reading

For a complete technical discussion of infrared photography, you may wish to read *Infrared Photography Handbook*, by Laurie White, or *The Art of Infrared Photography*, by Joseph Paduano (both available from Amherst Media, Inc.).

"... you will be best off focusing in a manual mode."

Environmental Portrait

□ Location

In an environmental portrait, such as "Wandering Spirit," the location that is picked is very important. In this case, a familiar spot was used. I had driven by many times but never knew what to use it for. The building sitting in the valley with its smokestacks gives us the feeling that this could be the subject's residence.

□ Clothing Selection

The outfit that the subject wears can also make the portrait tell a story. In this case, the subject had worn the witch outfit for a school musical and her mother wanted a photo with her in it. Here again, the black fabric of the outfit turned light so the walking stick and the necklace became more visible.

□ Camera Angle

The path already created in the grass seemed to be the perfect place to stand her. The camera angle was selected so the path led in from the bottom right corner. A lower camera angle was also used, ensuring that her head and shoulders stayed above the horizon line created by the field. This allowed the subject to become more prominent.

□ Lighting

The photo was taken early in the morning, which gave it its lighting impact. In the color photo taken at the same time, the roof of the lean-to attached to the building showed up quite bright against the dark green trees in the woods. In infrared it's hardly noticeable, as the trees are an even lighter value than the roof.

□ Printing

The final image, for my purposes, was printed on color paper in a brown tone.

"The photo was taken early in the morning, which gave it its lighting impact."

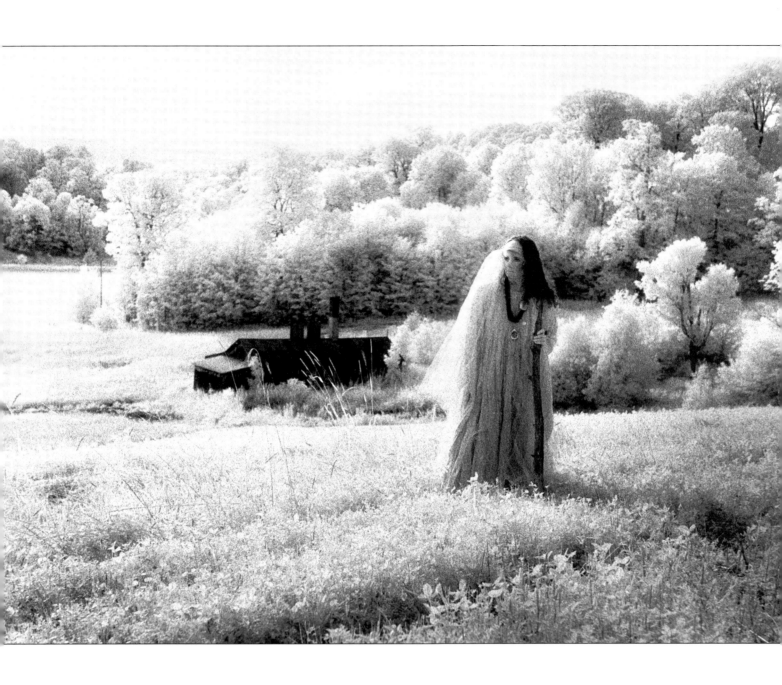

☐ Previsualization

Since infrared film does not record exactly what the eye sees, it is very important for the photographer to develop a sense of what the image will look like once it is exposed. A portrait that looks beautiful in black and white will not necessarily translate well into infrared. I find that looking through a 25A red filter when composing the image helps me to isolate what is going to look like what. The filter lightens the greenery, darkens the sky and water, brings out the clouds, much as the infrared film itself will do.

☐ Infrared in Different Locations

It's been my experience that different areas of the country do not record the same in infrared. Some areas appear to have more infrared in their environment than others. For example, here, the trees in the background do not reflect much infrared at all. As such, they don't appear much different from how they would look if they were shot in black and white. If this photo were taken in another area, however, the trees may have recorded much brighter than here, and appear more like the grass and foliage along the foot of the bridge.

☐ Film Type

Two film manufacturers produce black and white infrared. Kodak infrared film is available in 35mm and 4x5 format. Konica is available in 35mm and 120 format. While they produce similar results, under close scrutiny they are quite different. The Kodak film must be handled in total darkness while loading and unloading the camera body. This may require some practice. The film is more sensitive to infrared rays than Konica and has good blacks, a wide range of mid tones and good whites. The 35mm format has a wonderful grain texture when enlarged which I feel enhances the infrared look. The Konica film may be loaded and unloaded in subdued light. The film is less sensitive to infrared rays and has less mid tones. The grain is also less apparent in enlargements. For photographers who photograph most of their portrait work with 120 format, using Konica is quite a temptation. This portrait of Beth was photographed using Konica film.

"... develop a sense of what the image will look like once it is exposed."

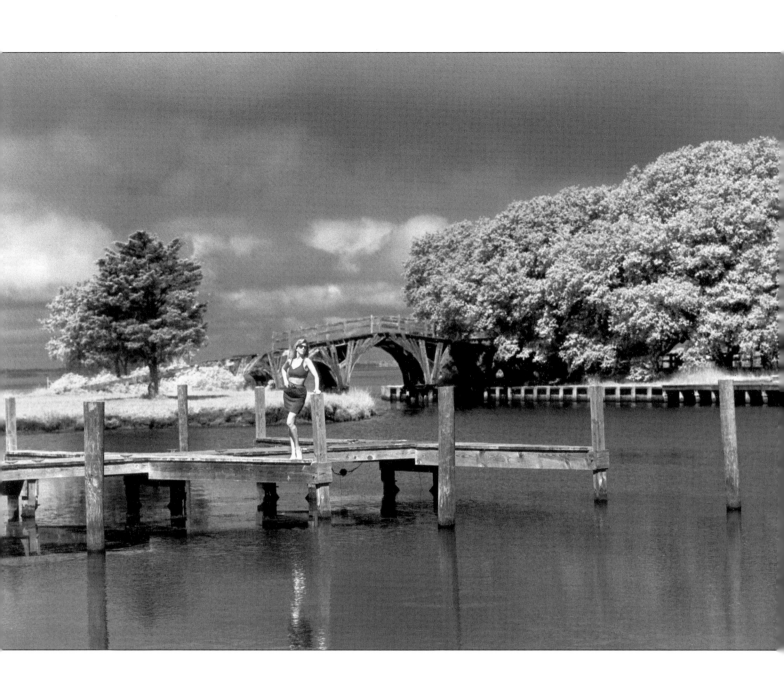

Metal in Infrared

☐ Series

This photo was taken for a series I was shooting on body piercing. I always suggest that photographers work on a series now and again. It keeps you thinking on ways to explore a theme, and forces you to flex your photographic muscles.

☐ Skin and Metal in Infrared

Infrared does wonderful things for the skin. It hides imperfections and blemishes, lightens the skin tone, and gives a general feeling of healthiness. However, on metal, infrared has no effect, which was ideal for this image. In color, the piercings wouldn't project as well as they do in infrared.

☐ Border

The border in this image was created in Photoshop. It was designed to compliment the subjects – shortening the man's nose a bit as well as lengthening the woman's stomach in a complimentary fashion. Although the image is good with or without the border, I feel that its addition adds a strength to the photo.

☐ Exposure

Since the #25A filter is always on my lens when using infrared film, I base my exposures with that compensation taken into account. I use an incident light meter at the subject. I meter both highlight and shadow areas. I like to keep no greater than a 2.5 stop difference between the two. Since it is a negative film, I usually expose for the overall or fill light source. When using Kodak film, the meter is set on ASA200 and for Konica, at ASA25. Since it is a light meter I use (not an infrared meter), I set my camera manually and always bracket my exposures – one stop underexposed, normal exposure, and one stop overexposed. If you decide to use the #87 filter, it requires one more stop of exposure (see page 46 for more on the #87 filter).

"... on metal, infrared has no effect..."

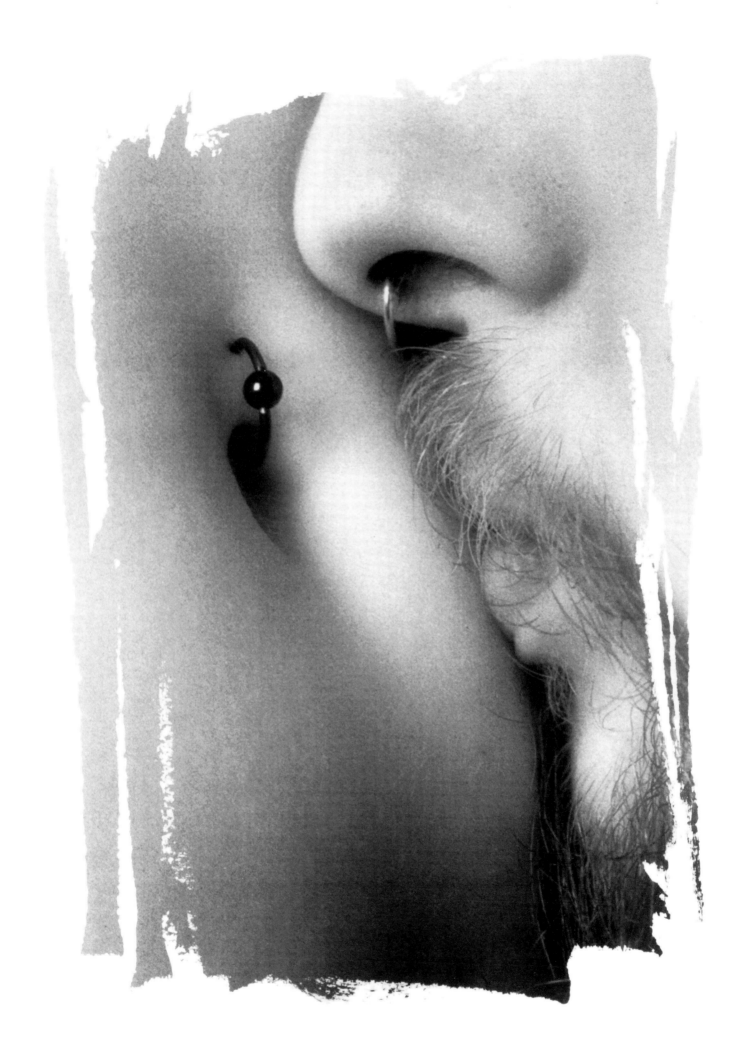

Fabric in Infrared

☐ Tungsten vs. Natural Light

This image was taken in order to answer a question that I have been asked during my talks and lectures. Namely, do you have to change filters if you use tungsten light with infrared film? The answer is no. I shot this using Kodak infrared film rated at 200 ASA with a 25A red filter on the lens. The light source was tungsten and the final image looks much the same as it would if I had shot outdoors using natural light with the same equipment. There is no noticeable difference in skin tone between tungsten and outdoor light.

☐ Fabric

Fabric in infrared can react in different ways, and is difficult to predict. For example, a pure black silk shirt may record on infrared film as white. However, it could also stay closer to its true tonality. There is no way of predicting what tones clothing or backdrops will record as in the final image. This means a great deal of trial and error can be in order for the infrared photographer. I was fortunate in this image, as the leopard spots on the dress and background did in fact record very closely to how they appeared in the studio, and didn't fade into the fabric of the dress.

☐ Surreal

One of the creative strengths of infrared film is its ability to turn otherwise average or ho-hum portraits into something truly different or surreal.

"Fabric in infrared can react in different ways, and is difficult to predict."

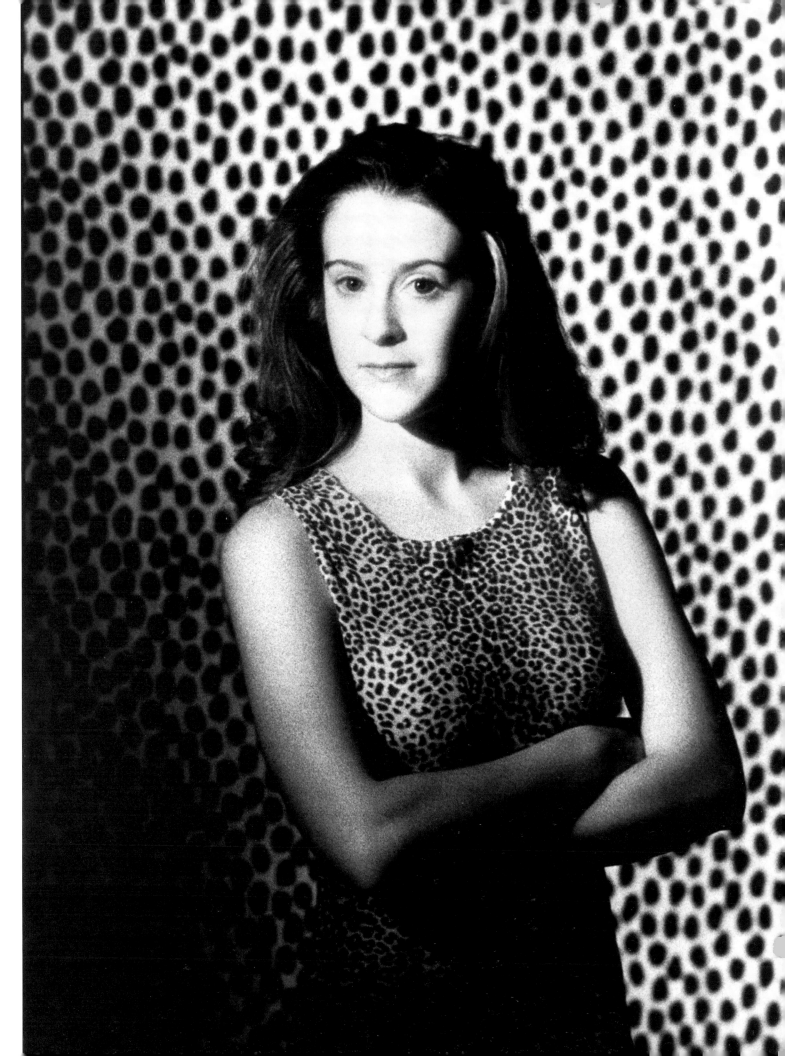

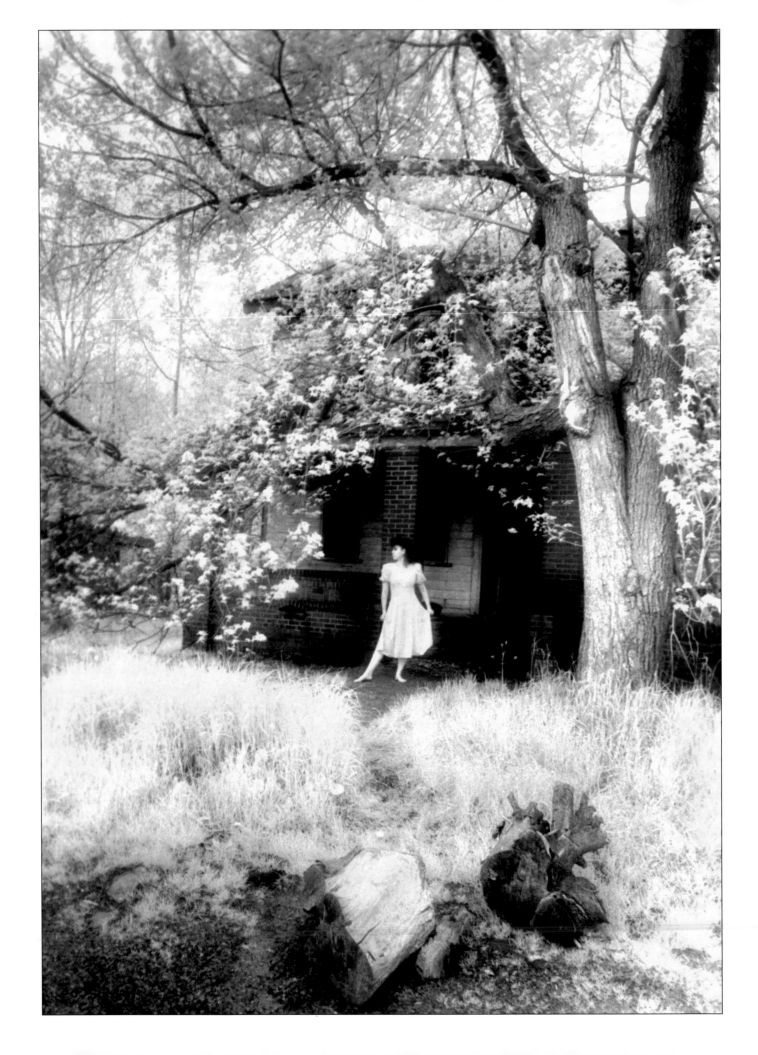

□ Spring Foliage

This photo was taken in very early spring as a test to see if new vegetation would show up in infrared as brilliantly as it does later in the season. As this example illustrates, even new foliage will give satisfactory images

□ Infrared Composition

The leaves and grass give a circular pattern which leads the eye in a spiral pattern towards the model at the image's center. This pose would not have been as effective without the infrared, as the dark vegetation and dark house would blend more together, making the model stand out too strongly from the background – unbalanced.

□ Bracketing and Infrared

As with normal black and white photography, images can often benefit from a bit of tweaking in the darkroom. The exposure for this image was very difficult to gauge, since the house was in such a dark area as compared to the model and the bright vegetation. I used a five stop bracket for the image. From this bracketing, I chose the image that had the best exposure for the house, and then burned in the grass and leaves until a proper image was created.

"... images can often benefit from a bit of tweaking in the darkroom."

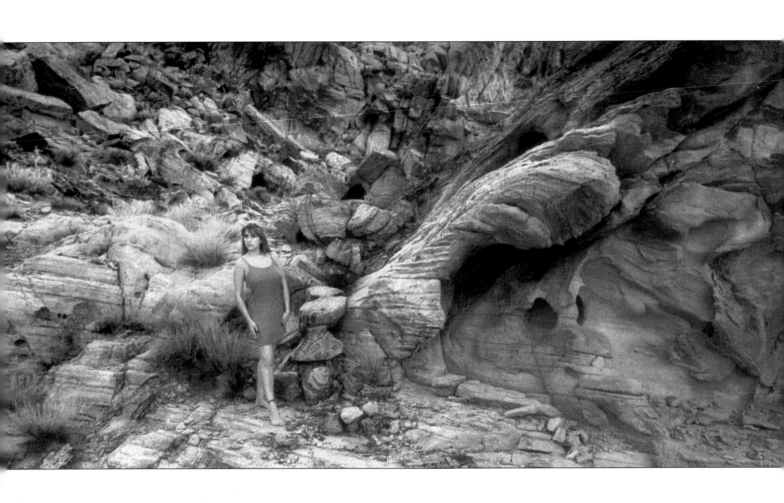

"Curiosity is a powerful driving force behind my photographic experiments..."

☐ Photographer's Curiosity

This photo was taken in Nevada, at The Valley of the Fire State Park. There was almost no vegetation in sight, juts a few pieces of scrub brush here and there. I came looking to shoot in this area because the rocks are a brilliant fiery red color, and I was curious as to how they would look when recorded in infrared, especially as the main background component (with the lack of vegetation). Curiosity is a powerful driving force behind my photographic experiments, and I believe that anyone who wants to become proficient at infrared photography should exercise a healthy amount of curiosity about what different sorts of things will look like in infrared.

☐ Composition

The placement of the model in the image was a very important consideration in this image, as there was the danger of having her lost in the final image – blending away into the rocks. The viewer's eye comes in at the upper corner, where the greatest contrast is, and flows down the almost wave-like rock formation, finally resting on the model herself.

☐ Previsualization

You have to keep in mind as a photographer the difference between what an image will look like in black and white and what it would look like in infrared. These rocks, for example, would have printed as dark gray if shot in black and white instead of the lighter and more compositionally pleasing tone that you see in infrared. My best suggestion for you as an infrared photographer is to keep your curiosity open, and to shoot as much as you can afford. Film, in the long run, is cheap, and will help your eye train.

☐ Bracketing

This image was shot at late evening, with the sun behind the hill, at 1/60th of a second at f5.6. I bracketed the image, and I recommend that in infrared you always bracket. I generally bracket at least three stops, sometimes more. While this isn't as important in a studio situation, outdoors it almost always pays off in the end.

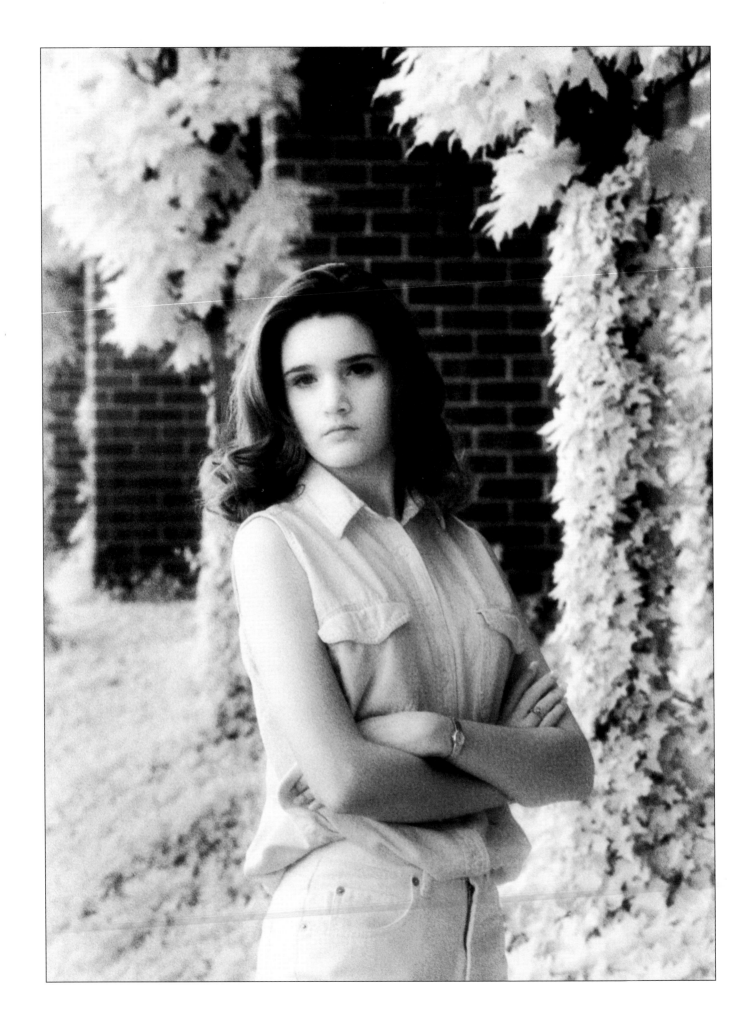

☐ Importance of Previsualization

This was a shot taken at a workshop, at the building where it was being held. I liked the combination of brick and vines, and knew an interesting shot could be made here in infrared. A situation like this is always a neat thing to shoot: the brick will usually keep its tonality, while the vegetation usually goes white, giving the image a classic and surreal look that is only available through infrared film. The trick again is to try to pre-visualize the image before taking the shot. Imagine what the white foliage will look like against the dark bricks, and place your model in a location that will be best suited to the infrared scheme. In this image, for example, knowing that the vines would go white in infrared, I didn't want to place the model in a completely dark spot of the frame, since the viewer's eye would then go to the white foliage first, instead of coming in from the left of the frame to rest upon her.

☐ Eyes in Infrared

A very important thing to be aware of when doing a portrait in infrared is the difficulty in guessing what a subject's eyes are going to look like in infrared. Some reproduce well, some do not. The only way to tell for certain is to actually photograph your subject and see how their eyes come out.

☐ Posing and Composition

This shot was taken with a Zeiss 50mm lens on a Contax 137 body with the light coming in from the left of the frame (the sun was hidden behind the building). I was standing on something in order to shoot from a higher angle above the model (to include as much of the vines as I could in the frame). I like to lean people at the waist in my portrait photography, but I didn't do it in this case, as I was looking to have her figure mimic the architecture behind her.

"... it is difficult to predict what a subject's eyes are going to look like in infrared."

☐ Infrared and the Client

With all of my high school senior portraits, I have the customer come in to my studio for a consultation beforehand. At this time we discuss the sort of sitting she'd like, as well as having her look through my book of previous work to see if there are any particular settings that she enjoys. In the case of this photo, she saw a portrait that I had taken of another student, and decided that she would like one that was similar. I have found that it is very important to be sure that your client sees examples of infrared portraits you have done in the past, before you simply assume she will appreciate the non-traditional look of the images once they are finished. Some people simply do not like to look of people in infrared, and you don't want your customers to lose their faith in your ability.

☐ Composition

This was one of two infrared shots taken of this model. It was taken in a hammock which I have up in my studio, against a white background. The light was from a 4x6 softbox with fill from an umbrella. The infrared film lightened her face considerably, and darkened her eyes, while giving the overall portrait a very soft pastel look, which is consistent with how most infrared portraits turn out. She was quite pleased with this finished image.

☐ Eye Direction

I've found through experience that, when taking an infrared portrait very close-up, as in this photo, you should have your subject look about six inches above the lens. In the finished image, it will look as though your model is looking directly into the lens.

"... I have the customer come in to my studio for a consultation beforehand..."

☐ Rust and Infrared

There is just something about a rusted-out piece of metal that draws my eye, and I know it isn't just me, since a great number of my clients like to be photographed in front of this old truck. I bought it at a junkyard and hauled it out to my studio. The key to shooting objects like this is to remember that metal (even rusted metal) doesn't reflect infrared, so it will record as a rich dark shape while everything around it records in glorious infrared.

☐ Composition

The placement of the truck and the client are key to the composition here, as is the case in a lot of outdoor infrared portraits. The client's body and head are positioned so that they are surrounded by the metal of the truck in the image, or else she would fade into the similar tonality of the foliage in the background. The nose of the truck is situated so that it protrudes into the sunlight coming through the edge of the leaves overhead, giving the headlight a nice punch which helps to lead the eye to the subject.

☐ Advantages of Infrared

This photo is much more successful in infrared than it would be in color, or in black and white. The truck stands out from the trees and grass in infrared, where it would otherwise have a tendency to fade somewhat into the background of a normal photo.

☐ Bracketing

I did a five stop bracket of this image, to find a balance where I could dodge the truck out in printing to get all the details, burn in the foliage, and still have nice tonality on the subject.

"There is just something about a rusted-out piece of metal that draws my eye..."

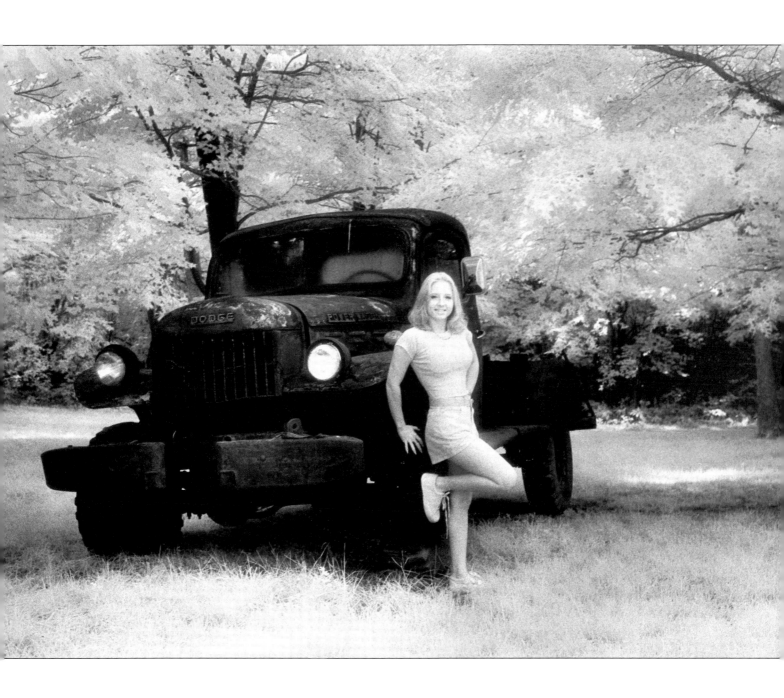

Infrared Wedding Photography

□ Wedding Consultations

During the consultation session with the bride and groom for the wedding shoot, the couple saw some of the infrared work I had done at similar occasions, and decided they would like some done for their wedding as well. This is not completely uncommon for a wedding shoot, although the majority of the photos are still taken with normal film. Infrared is like a dessert after a meal: a little can go a long way.

□ Romance and Infrared

This is my favorite image from the batch I shot for this wedding, including the color images. There is a definite sense of romance here, a softness that only infrared can capture. It was taken on a nice summer's day, although there is a thunderstorm moving in from the left side of the image. The group photos were taken at another location, saving this one for the shots of the bride and groom together, in front of the bridge which symbolizes the transition from single life to married life.

□ Composition

The vegetation covers a wide range of tonality, from the white of the lily pads in the water to the darker grays of the trees at the right of the frame, illustrating the wide range of infrared reflection you can get from different species of plantlife. Notice that the railings of the bridge and the horizon line do not go through the bride's head – this would be a compositional no-no. You must remember to keep the general rules of good composition in mind at the same time as you are factoring in the added ingredients that come along with infrared film.

□ Technical Information

The image was taken with a 28mm Yashica lens on a Contax 137camera body, bracketed, and the background was burned in when making the final print.

"Infrared is like a dessert after a meal: a little can go a long way."

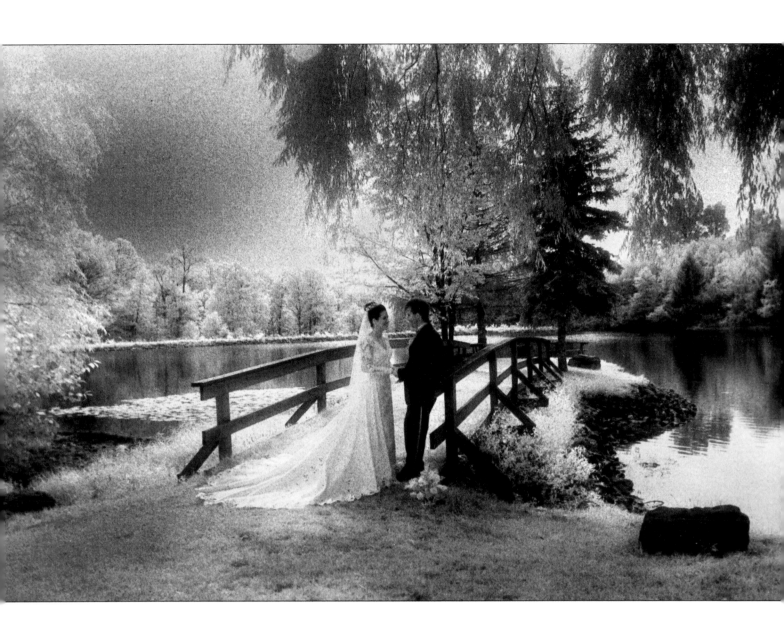

□ Story Behind the Image

This photo was taken during my series on body piercings. The model asked me if I would make a very dramatic image for him, and never one to turn down a challenge, I obliged.

□ Technical

This image was taken in my studio, with the light coming from a 4x6 softbox. I normally don't bracket in the studio, but this is one of those "exceptions-to-the-rule" sorts of situations. Since I was exposing for the highlight in the image and wanted to get the most dramatic image possible, I bracketed to find the proper exposure.

□ Advantages of Infrared

This image is softened by the infrared, having a more pastel sort of look than you would get with black and white film. The detail in the pants is stronger than it would be in black and white as well, and the skin has a more "Oooh, neat!" look than you'd normally get. Infrared is especially good for recording highlights and gives grayer shadows than in black and white.

□ When Infrared is Preferred

I like to use infrared when I want an image that is different. Black and white is real, where infrared is more surreal. Combining a simple pose like the one in this photo with dramatic lighting, you change something that might be otherwise ordinary into something extraordinary.

□ Fabrics in Infrared

Words of wisdom for you: trust black muslin as a fabric for your backgrounds. It's been my experience that it stays black when you shoot it in infrared, whereas other dark fabrics can go an unexpected gray, and ruin what might otherwise be a fantastic portrait.

"Trust black muslin as a fabric for your backgrounds."

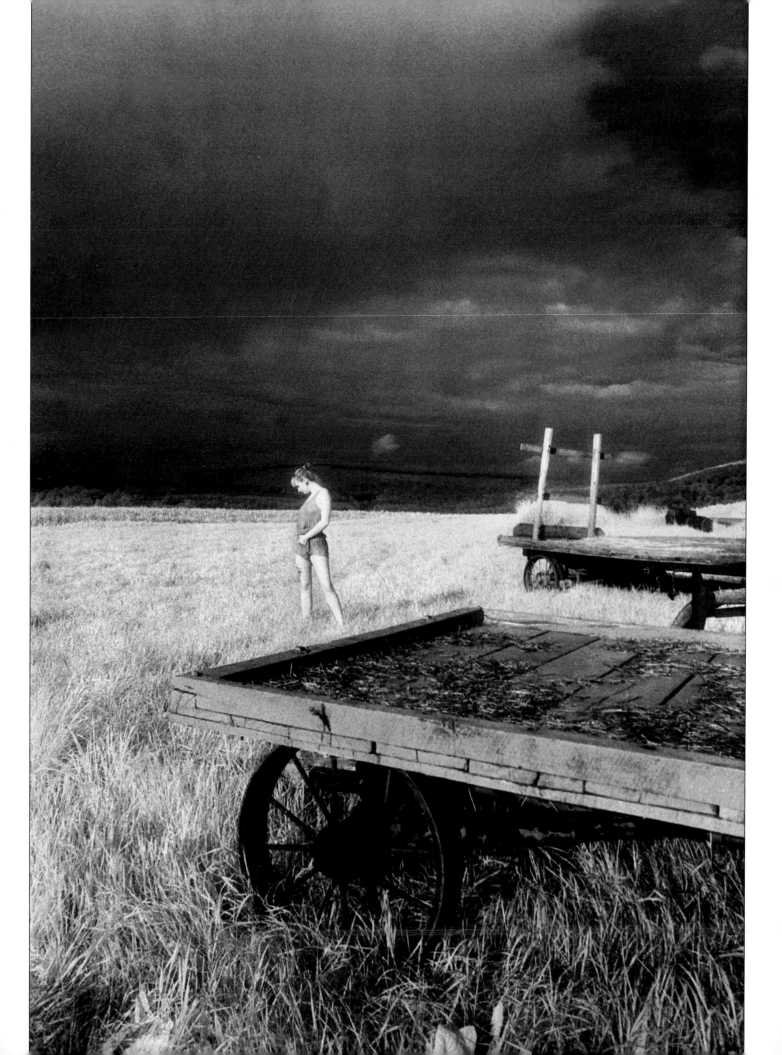

□ Story Behind the Image

This was a location I found while out on a drive with the model. She is from a big city, and was truly impressed by all the wide open spaces out in the county. I wanted to take a portrait of her that reflected this awe with the great open spaces she was touring.

□ Composition

Compositionally, it was important to include the wagons and especially the wagon wheels, rather than focusing on the model alone. In addition to reinforcing the idea of being in the country, the diagonal of the wagon draws the eye to the model. Care was taken to shoot the horizon line from a relatively high position. This helped to keep the wagon in the foreground from appearing too large and becoming the focus of the shot, instead of the model.

□ Horizon Lines

Horizon lines are also very important in infrared photography, since there is such a strong delineation made between the horizon and the sky. To help you visualize the importance of this, try looking through your red filter when composing the shot. You'll get a better idea of what to expect when the image is printed.

□ Cut Foliage in Infrared

Foliage can reflect infrared for some time after it is cut down. Notice the hay on the wagon in the background. It's still giving out that distinctive infrared look. I don't have a rule of thumb for you as far as how long cut plants will reflect infrared, but my experience has been that cut grass will show infrared at least three days after cutting.

□ Tattoos

One last note: tattoos really zing in infrared. The model has one on her right leg, and it's very distinct in this image. If you've got any friends with tattoos, I'd suggest giving some attention to photographing them. A series, anyone?

"Horizon lines are also very important in infrared photography..."

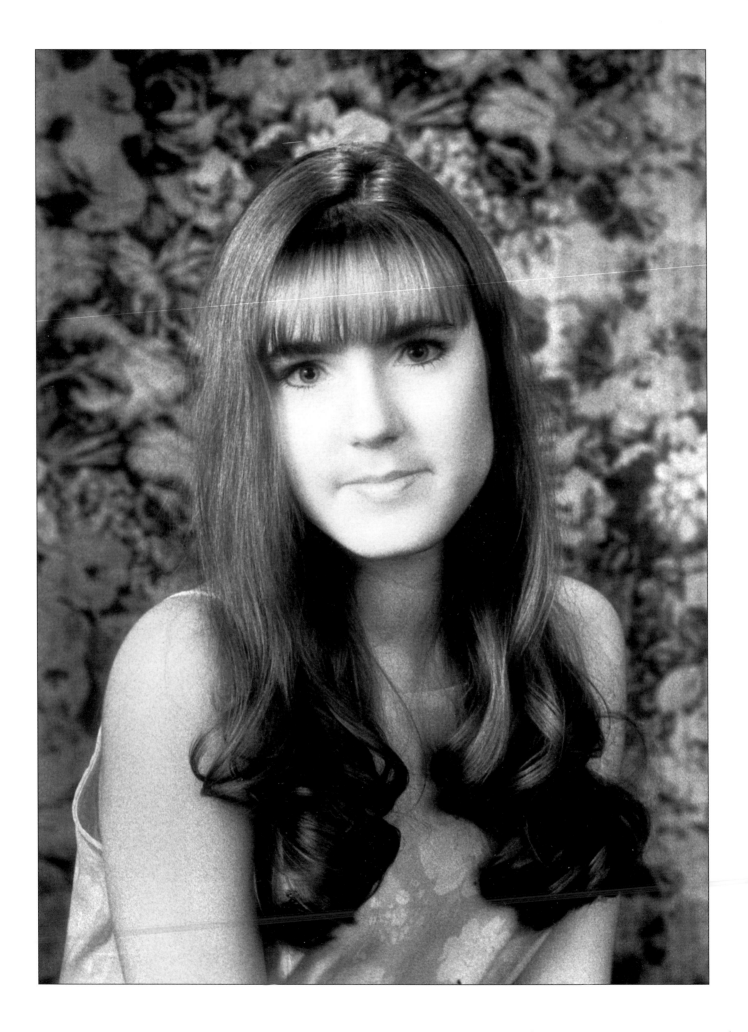

□ Story Behind the Image

This is a sitting for a senior portrait, done in my studio, with a pose selected from a photo in my book that I use during consultation. For this shoot, I shot color photos as well, since you can never be completely sure that a client will like the resulting infrared portrait until you show it to her (for the record, she liked this one the best, and ended up buying wallets).

□ Fabrics in Infrared

The lighting is from a 4x6 softbox, with an umbrella fill and hair light. The model was wearing a red and brown dress, and the background was selected to match the color of the dress. This is a good example of the difficulty in guessing what a fabric will look like in infrared. You can't judge what you'll get just from the color. See how much lighter the dress is in infrared than the background?

□ Make-Up in Infrared

The client is wearing mascara, eyeliner and a dark eyeshadow, which is a good make-up choice for infrared. Otherwise, it's quite possible that you'll lose too much drama and emphasis on the eyes in the final print. As for other make-up, it's been my experience that browner, earth colors record much better than any others, and are a good choice to emphasize the contours of the face. Light red lipstick should be avoided, since it tends to go white, which can give a look to the subject that she might find unsettling. Also, the red filter will absorb the color as well, so all your hard make-up work could well disappear without leaving any trace!

"Light red lipstick should be avoided..."

☐ Story Behind Photo

This is a portrait of the Sommerset County Lamb and Wool Queen. She wanted photos of herself with the sheep she was raising for an entry in a 4H contest. We shot images in both color and in infrared.

☐ Adding Light to Image

When using reflectors with infrared, I've found that bounced light doesn't always give infrared to the face. However, bounced light from foliage can help to bring it out. Fill flash usually just adds a highlight to the eyes.

☐ Composition

As an artistic shot, infrared makes this a better image than color. The subject is more separated from the background than she would be in color, and the same goes for the sheep as well. Notice that the horizon line does not go along the sheep's feet. This is to make them more prominent in the background. The trees behind the subject's head temper the horizon line somewhat around her as well.

☐ Suitability of Infrared

You will find as you experiment in infrared portraiture that infrared will not always work for what your client has in mind. While the client liked the infrared images of her, and thought them very pastoral (focusing the attention on her and the lamb), she decided to send the color images to the judges of her contest because they more realistically detailed the sheep, giving information as to breed, health, etc. Again, as I've said, infrared is surreal, not real, and as such isn't always appropriate for your client's usage.

"... infrared is surreal, not real..."

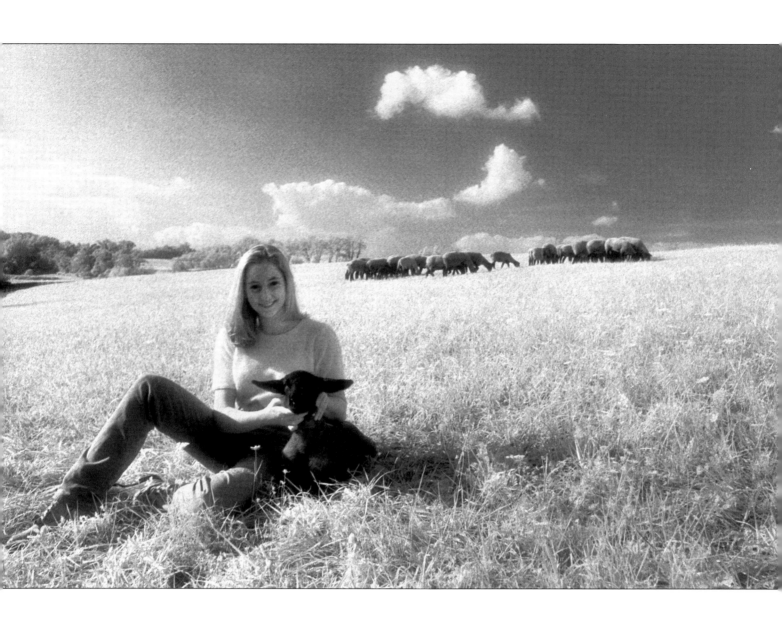

Skies in Infrared

☐ Story Behind the Image

This was taken at a lovely location out west in Colorado. The abandoned farmhouse in the summertime under these great big puffy clouds gave a wonderful sense of desolation and loneliness to the image.

☐ Composition

The pose of the model and the area just around her were very important considerations for the composition of this image. I had her keep her pose simple, kneeling in the grass (standing didn't seem to fit in with the mood here). The pose felt best when factored in with the overall image. However, it also meant I had to pay particular attention to the grass around her. While in the real world this grass was dull brown summer grass, in infrared it recorded in white. There was a good chance that it could have been distracting if it were too prominent in front of the model, so I trampled it down around her. I was also very sure to photograph her from such an angle that the barbed wire does not appear to "cut" into her face. Issues like these are important for all photographers to keep in mind.

☐ Clouds in Infrared

Infrared is a great film for shooting clouds, and this seems especially true in the west. The blue skies go dark, which gives the clouds a wonderful bite. Again, to get a good idea what the sky might look like in the finished image, view the scene through your red filter beforehand.

"Infrared is a great film for shooting clouds..."

☐ Technical Info

This image was taken with a 28mm Yashica lens on a Contax 137 body,. The exposure was 1/125th at f11. I used Kodak infrared film rated at 200 ASA, and bracketed several stops.

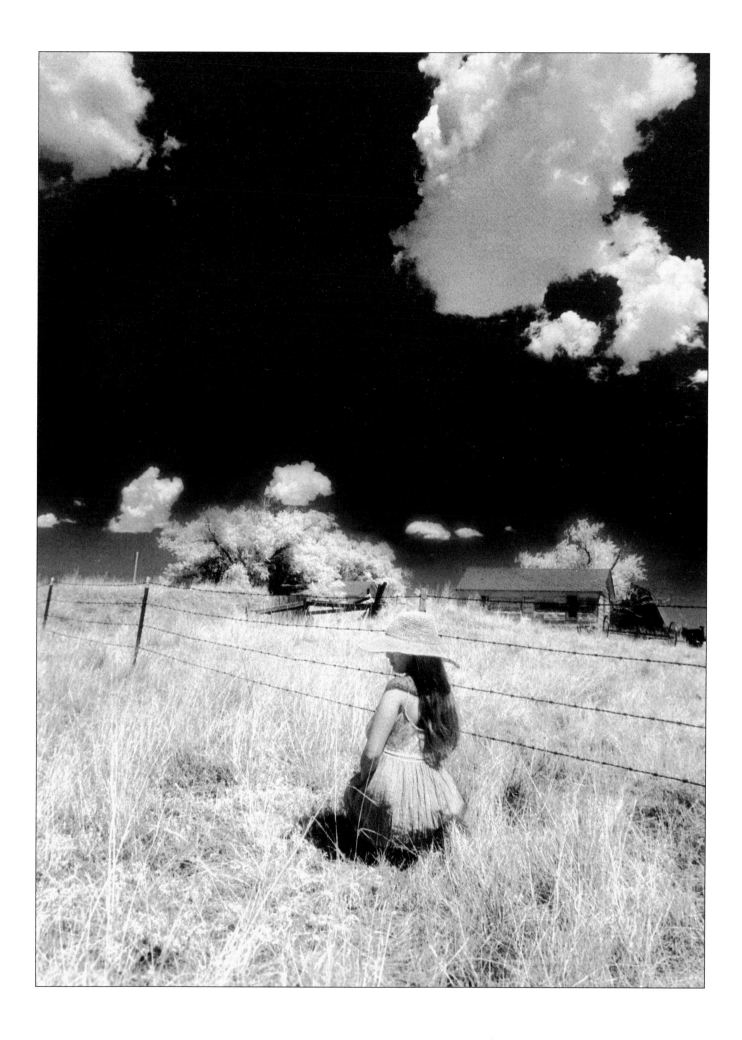

Infrared Over Color

□ Composition

This image was taken at White Sands, New Mexico, in the early morning. The sun is giving texture to the sand, emphasizing the lines which go up through the sand and to the subject. The clouds command our attention to the left side, and again lead to the subject. The low angle was chosen to eliminate the other dunes in the background. The model contrasts with her environment, rather than harmonizing, because of her dress, and by the sheer vastness of the sandy area. The viewer asks, "Why is she here? Where is she going?" She is not in your typical model pose, with her hands at her side and not her hips, and appears very relaxed.

□ Advantages of Infrared

This photo looks much better than it would in color. With the blue sky, green foliage, tan sand and green dress, it's really a rather drab image in and of itself. However, in infrared, it packs a much better punch. The sky jumps out at you, and isn't as washed out or drab as a color image, and more importance is placed on the lines within the image rather than the individual pieces themselves.

"... in infrared, it packs a much better punch."

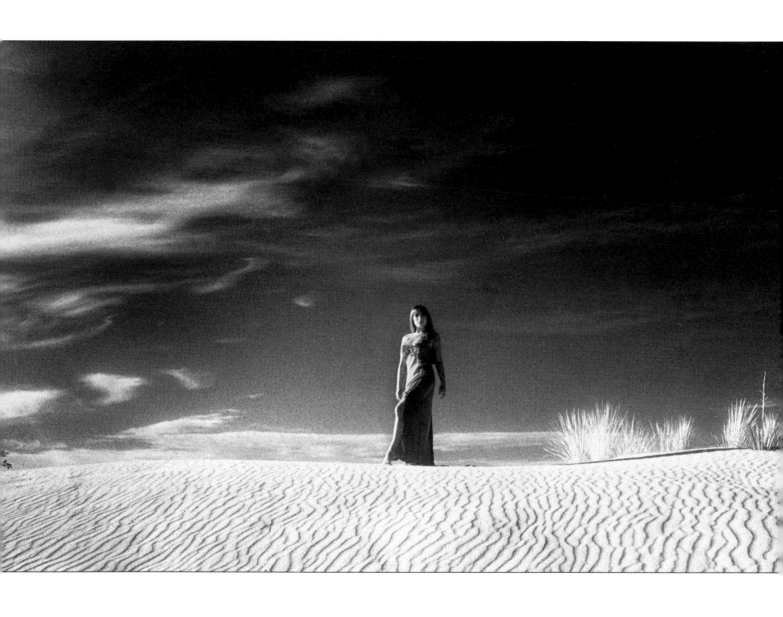

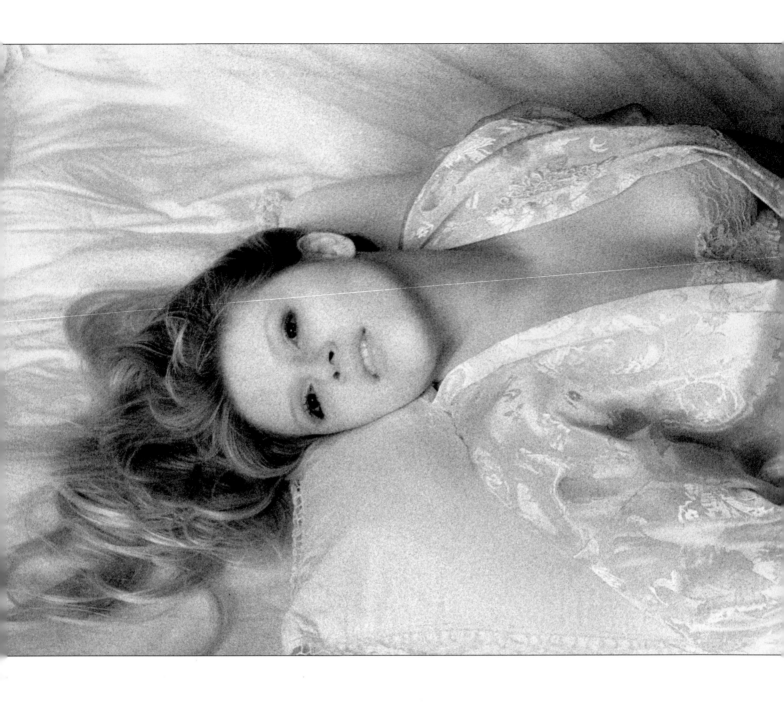

□ Composition

This is a glamour shot taken in the studio on a bed covered in a white comforter. The pose flatters the model's face, neck and chest, and the infrared lightens her hair. Her eyes reacted very nicely indeed to the infrared, going beautifully dark (as I knew they would, from previous experience shooting this model in infrared). The light is from a 4x6 softbox, with fill from an umbrella.

□ Choices for Infrared

I used infrared here in order to give the image a dreamy, grainy look without the high contrast that would have resulted from using black and white. Additionally, I knew that in infrared, her clothing (mostly blue, lavender and pink), would more than likely lighten up to more closely match the lighter-colored bed and comforter.

□ Subtlety

Sometimes the portraits you shoot in infrared will not be immediately obvious to the average viewer as anything other than a normal black and white shot. Obviously, this isn't always a bad thing, as this photo illustrates. You get a lot of the benefits of shooting with infrared film (clearer skin tones, softer image), without that quality of otherworldliness that can make some people uncomfortable. This to me only illustrates how flexible infrared film can be to someone experienced in shooting it – and the only way to get that experience is to keep shooting!

"... give the image a dreamy, grainy look..."

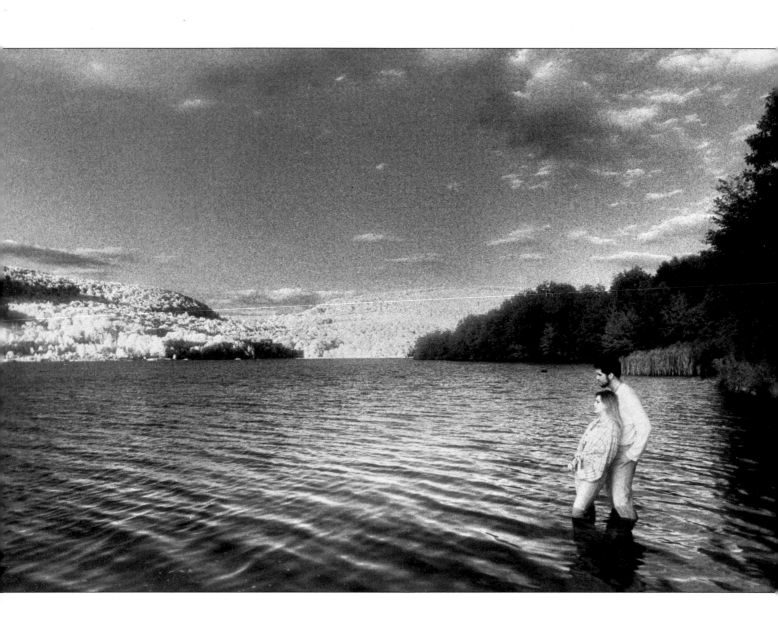

☐ Composition

The couple in this photo are an artistic pair. For a portrait that they asked me to shoot of them, I knew they'd really like to have something that was unusual. With that in mind, we went to this beautiful lake, and in they went! The water was very cold, but they were real troopers about it. The resulting image was certainly worth the chills. I had the woman hold her shirt in her hands so as to keep her arms from merely hanging limply at her sides, and had her lean back against the man, to give the impression of him holding her up. On a pure wardrobe level, the fact that they are in their street clothes while standing in a lake only adds to the level of absurdity here. With the addition of infrared to this equation, the unusual image I had in mind is complete.

☐ Technical Info

This image was taken with a 28mm Yashica lens on a 137 Contax body shot at f5.6 at 1/125 of a second. The sun was setting behind us, shining on the hills in the background, but leaving the couple in the shadow. This led to me having to do a bit of work in the darkroom to get the photo properly printed. Having bracketed, I chose the image with the best-exposed sky and mountains, then printed for the sky, while dodging the lake and the couple for the final print.

☐ Water, Skies and Infrared

Infrared film was an easy equipment choice for this image, and not just for the stereotypical "glowing foliage/surreal skin" reasons. With infrared, the water in the lake is much darker than it would be in a black and white image. Combined with the darker sky and more prominent clouds, this makes for a very strong image (while it isn't a rule, you can usually count on infrared to have the same effect on water as it does the sky).

"... I chose the image with the best-exposed sky."

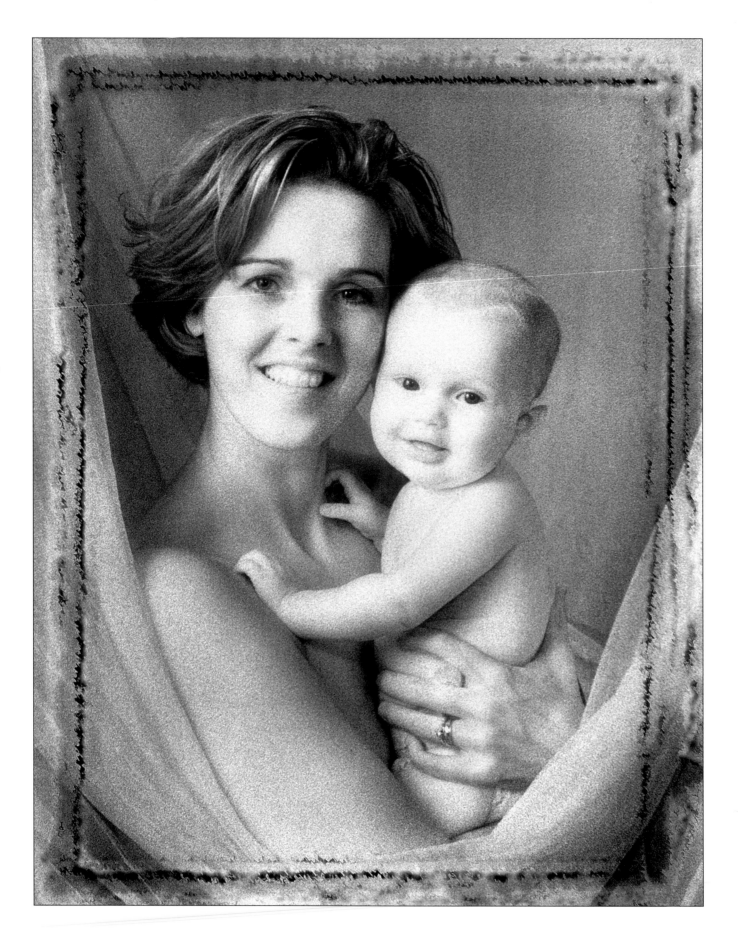

"Fabric can play an important role as a prop in any portrait."

□ Story Behind the Photo

This is a portrait of Lisa and son, Caleb. She has had sittings with each of her other five children, so of course she had to have one with Caleb as well. The tricky part of this was that Caleb had been born with a birth defect which required a tracheotomy to allow him to breathe. In the portrait that she took home with her, the trach is apparent, since she wanted to record the boy as he truly was at that period in time. For the book and my studio portfolio, however, I preferred to have an image with the trach digitally removed.

□ Fabric and Experience

Fabric can play an important role as a prop in any portrait. For this one, I used tricot fabric in the background and a nest of it around her arm to help project a feeling of comfort, warmth and shelter to the image. Again, when shooting in infrared, keep in mind that predicting how a fabric that you've never used before is going to look is a difficult task. Experience will help you in the studio when using the same fabric backgrounds again and again.

□ Borders

I used a 4x6 softbox for the main light, with an umbrella fill, and a hair light on the mother. The infrared film helps to keep the photo light and airy, and to make the skin tones more pleasing (black & white would have made her tones a bit more dark and ruddy, and Caleb's as well, though not as strongly). The border was created in Photoshop®, and designed to keep the integrity of the photo itself, unlike the image on page 11 (of the pierced navel and nose), where the border was intended to strengthen the image itself. All in all, this was a special photo of a special baby.

Infrared's Effect on Skin

☐ Lighting

I took this image of an artist and her paintings while in Cancun, Mexico. It was taken in her living room, and we simply moved her furniture away from the white wall and posed her against it, between the two paintings. The main light was sunlight streaming in through a nearby window, but that alone created too harsh of a shadow on her left side. The solution here was to turn on the room light, which made for a nice fill (you don't need to worry about color temperature with infrared film, just as you don't with normal black and white either).

☐ Composition

As with any artistic portrait that you shoot, you need to pay attention to the idea you are trying to convey as well as taking care of the purely technical concerns of the image. Here, I was trying to draw a correlation between the artist and her art. She is dressed in a black t-shirt, which has a design on it which seems to mimic the paintings behind her. Her pose is also reflective of the artwork, being casual and relaxed without being smiley and happy. The distinctive infrared skin tones and graininess lend the artist a surreality which makes her more at one with the paintings as well.

☐ Infrared and Different Skin Tones

As you have seen, infrared film lightens skin and helps to hide imperfections. This isn't an effect which is limited to caucasian skin tones, however. Every skin color reacts in a similar method, although the tones do not lighten up to such an extent that the person's ethnicity can no longer be recognized.

"... infrared lightens skin and helps to hide imperfections..."

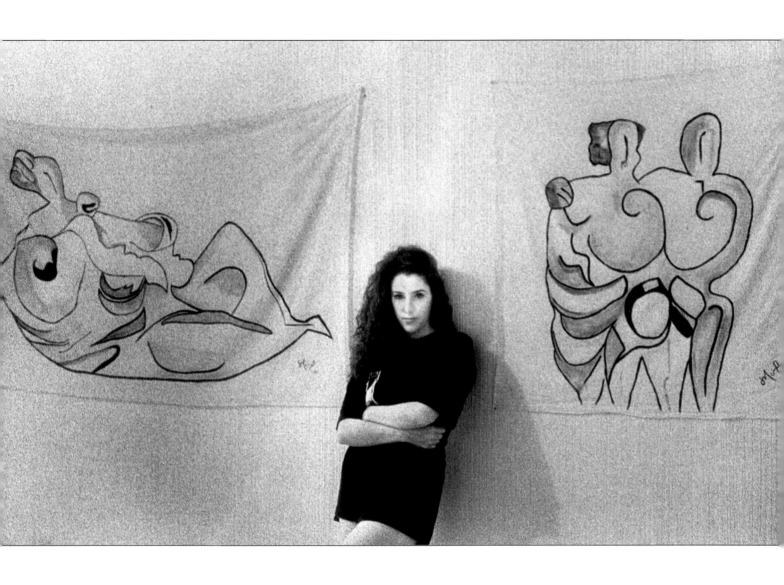

☐ #87 Red Filter

I have been asked before what the advantages are to using a standard #25A red filter versus an #87 red filter (which is used exclusively for infrared photography). The #87 filter appears completely opaque to the eye, and it blocks all light from hitting the film except for the infrared spectrum.

☐ Different Effects

The image at the top of the opposite page was taken with the #87 filter, while the one at the bottom was shot with the #25A red filter. As you can see, the foliage on the top image shows a much more distinctive infrared look, and the model's skin is just slightly lighter in tone. The dress (a gold and yellow smock, similar in color to the building behind her, the green thread design matching the color of the foliage) has gone lighter in the top image, although not to a large degree.

☐ Which is Better?

In my opinion, using the #87 filter for portrait photography isn't worth the effort and loss of control. Since the filter is opaque, you have to set your focus before attaching the filter, since obviously you can't see anything through the lens after that. It's harder to work with a model as well, since you lose the ability to adjust the pose while looking through the lens. Also, you lose an extra stop of light. While the #87 filter can be a helpful tool for landscape infrared photography, I don't feel that for portrait photography the slight gain in infrared reproduction makes up for the losses in the composition department.

"... the #87 filter for portrait photography isn't worth the effort and loss of control."

☐ Filter Usage

This was another photo taken during my stay in Cancun, Mexico, and it is an exercise in textures: in the concrete balls and the base they are resting upon; in the wall; the fabric of the model's garment, and so on. It's also an example of how you can use all the filters that you normally use in black and white (soft focus, multi-image, star focus, etc.) just as well in infrared film, and get just as pleasing a result.

☐ Soft Focus Filters

Soft focus filters really soften infrared images, as this image illustrates. The texture in the balls would have been too sharp and distracting in pure black and white or color, but in a filtered infrared, they are soft and dreamy. Additionally, the walls are softened, as is the model herself, leading to a pure dreamy image that draws the eye.

☐ Eyes in Infrared

I said earlier that not all model's eyes do well in infrared, and this is an example of that. There isn't any way ahead of time to know if a model's eyes will record well. Only actually doing a portrait with infrared will let you know. However, in this particular case, it all worked out compositionally in the end, since her soft eyes match with the soft spots in the concrete balls, giving a nice balance to the overall image. Was it planned that way? Well, no, but there's no reason for anyone but yourself to have to know that!

"... you can use all the filters you normally use in black and white just as well..."

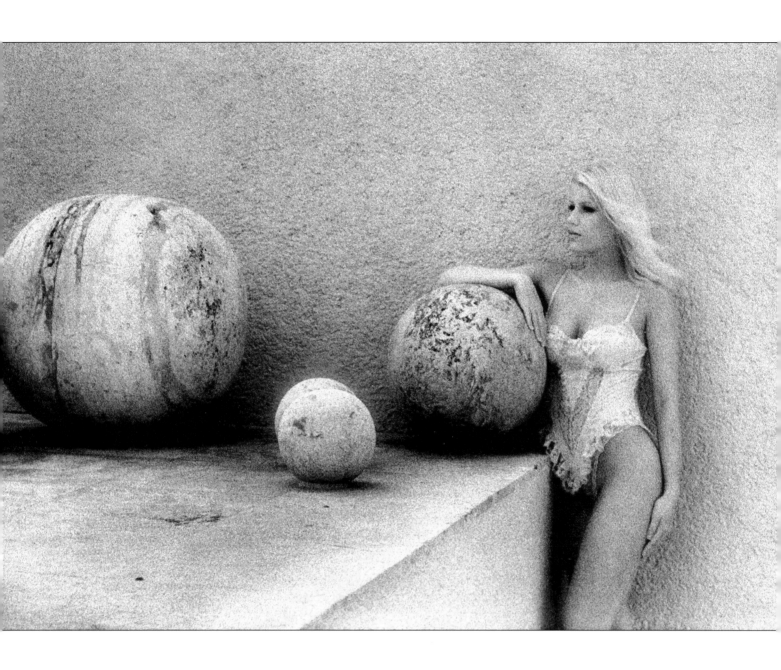

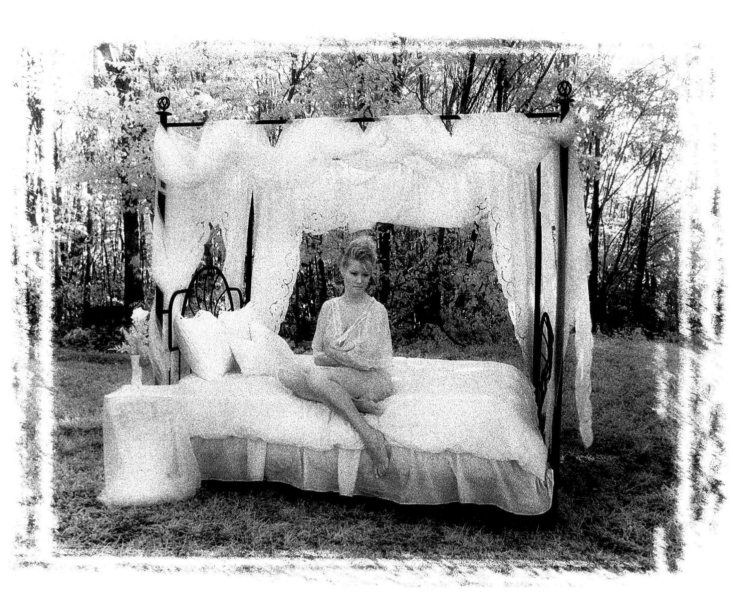

□ Composition

I wanted to make a more unusual sort of boudoir photo, even beyond the idea of an infrared portrait, and so I hit upon the idea of moving this bed from the studio to the outdoors. It's a lovely romantic prop, and the wrought iron really stands out in infrared, which wouldn't be so much the case if this shot were done in color. The iron would fade into the trees in the background, rather than being brought forward as the foliage goes white. Remember that metal doesn't reflect infrared, and you'll be better set to previsualize what an image is going to look like when printed.

□ Scanning and Outputting

I wasn't quite pleased with the image once I printed it, finding the trees a little too vertical and too distracting. So I scanned the photo and added the border effect in Photoshop. This helped to tone down the verticals and also gave the image a more artistic look. I've found when scanning an image, altering it in some way, and then outputting the new image to a negative that you lose some of the subtlety of the grain. To correct this, I add some noise back to the image, again in Photoshop, in order to restore some of the graininess to the photo.

□ Infrared and Skin Tone

This portrait was taken in summer, and although you can't tell from this image, the model had developed a nice dark tan. Why can't you tell? Because again, infrared film lightens the skin, something to always keep in mind when doing a portrait. In this case, I used that to my advantage, making her skin more closely match the tone of the comforter.

□ Technical Info

The light in this image was from the open sky. The photo itself was taken with a Yashica 55mm macro lens on a Contax 137 body, at 1/60th of a second at f8. I made sure when composing to keep some space between the model's head and the curtain above it.

"... I scanned the photo and added the border effect in Photoshop."

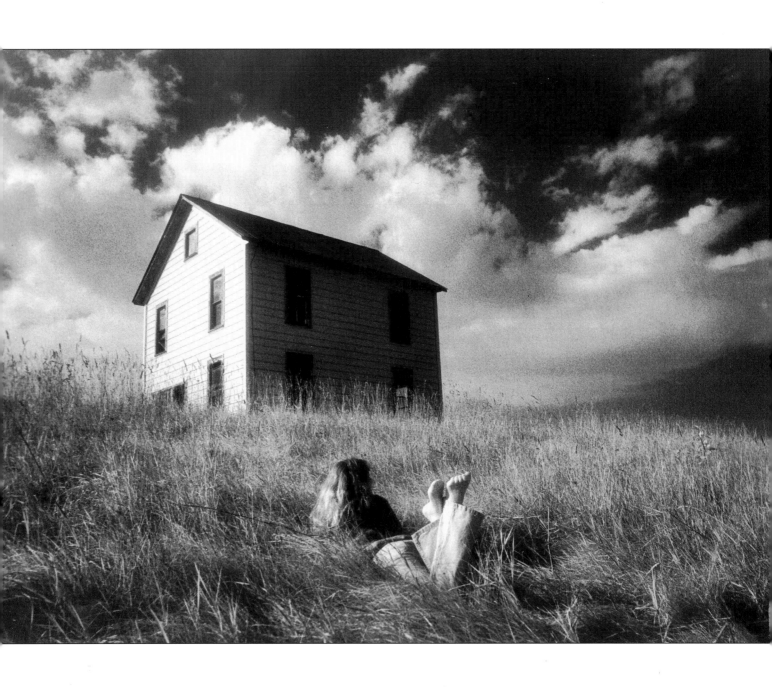

"Cloud formations... can bring success to an infrared photo."

☐ Clouds and Skies

I've said it over and over again throughout my career, and so I'll say it again: cloud formations and their placements in the frame can bring success to an infrared photo. In this image, for example, I felt that the clouds would compositionally draw the viewer's eye into the house. With the way that infrared brings the clouds out so strongly from the sky around them, I knew that I had the makings of a very fine image indeed.

☐ Strengthening Subject Matter

While the house against the clouds is an interesting image, the addition of the model only adds to the dramatic impact of the piece, adding a great deal to the story and many questions for the viewer as well. "Is this her house? An ancestor's? Is she dreaming of fixing the house up, or merely relaxing after a nice enjoyable picnic?" A good photo can raise as many questions as it answers.

☐ Models and Their Comfort

It was very important to keep the model's body at such an angle to the camera that her body received equal illumination and had no distortion or foreshortening to it. Also, great care was taken to watch for any high pieces of grass that would be distracting or come between the subject and the camera. I always make as much effort as possible to be sure that the model experiences no undo discomfort, to the point where I will lay down in the spot I want her first, just to be sure that there are no rocks or thistles that could make her uncomfortable. If you want to ensure a good working relationship with your models, I suggest that you exert as much effort as possible in keeping them comfortable and happy.

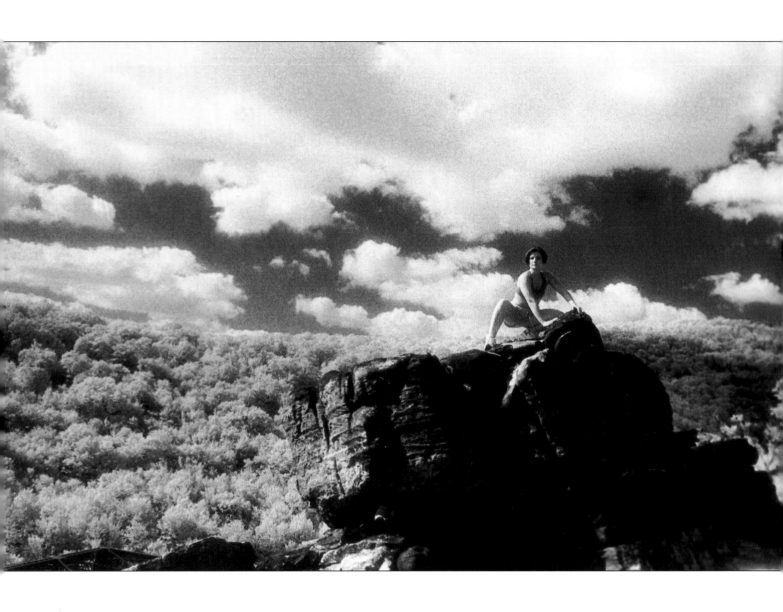

☐ Composition

With the subject contained in the sky area, it's very important to wait for the clouds to move into the proper position. On this particular day, the clouds were moving left to right, so I waited for the white clouds that are to the subject's left to come from behind her head so that, from her shoulders up, she was against the blue sky. In this way, we can see the lighting on her face as she stands out against what is actually a very, very busy background. If your eye follows the treeline, which acts as a horizon line, you notice how it comes in slightly higher on the left, and then gently sweeps down towards the subject. With the extreme contrast of lighting, it was impossible to keep detail in the shadow area of the black rocks, and so that area was dodged out somewhat in the printing. Just the rough tops of other rocks are visible on the left side, to give a feeling for where the model will be moving off to next.

☐ The Pose

The model, Liz, is a very athletic person, so the pose here is very aggressive. Her left forearm and hand are placed so that they don't go into shadow. The stance is such that the viewer can visualize her leaping off somewhere just after the shutter snapped. It's a very dynamic and powerful pose, denoting health, fitness and strength.

☐ Fabric and Infrared

As another example of the unpredictability of clothing reproduction in infrared, it should be noted that both the model's top and her shorts were black in reality. In the photo, the top stayed black. However, the shorts went a much lighter gray.

"It's a very dynamic and powerful pose..."

Child's Portrait

☐ The Clinger

This child's portrait was taken in her mother's arms, in my studio. It was taken at a time in her life when she was what I call a "clinger" – everything is quite alright as long as she gets to hold on to mom.

☐ Composition

As we view the photo, the mother's arm serves as the base of the photograph leading in from the left, and going to the upper right. The tricot fabric that serves as the background has folds that also come in from left to right, ending at the child's face. The little black triangle just above the girl's shoulder helps to balance the darkness of her eyes.

☐ Lighting

The light source is a strobe with a regular reflector bowl aimed through a white bed sheet, and a strobe bounced into a white umbrella is used to fill in the shadows.

☐ Film Grain

While I did color shots as well as traditional black and white photography during this session, this infrared shot seems to convey a special closeness of the child to the mother. I feel the graininess of the Kodak 35mm infrared film really adds to the character of this shot. The way the eyes react to the film (making them very dark), helps to tell the story of the child's dependence and need for security at this point in her life.

☐ Serendipity

Smiling at me and playing peek-a-boo was a nice way to get a few good shots of the girl, but the instant the little hand came up and squeezed the folds of her mother's nightgown, I knew I had a great portrait.

"... convey a special closeness of the child to the mother."

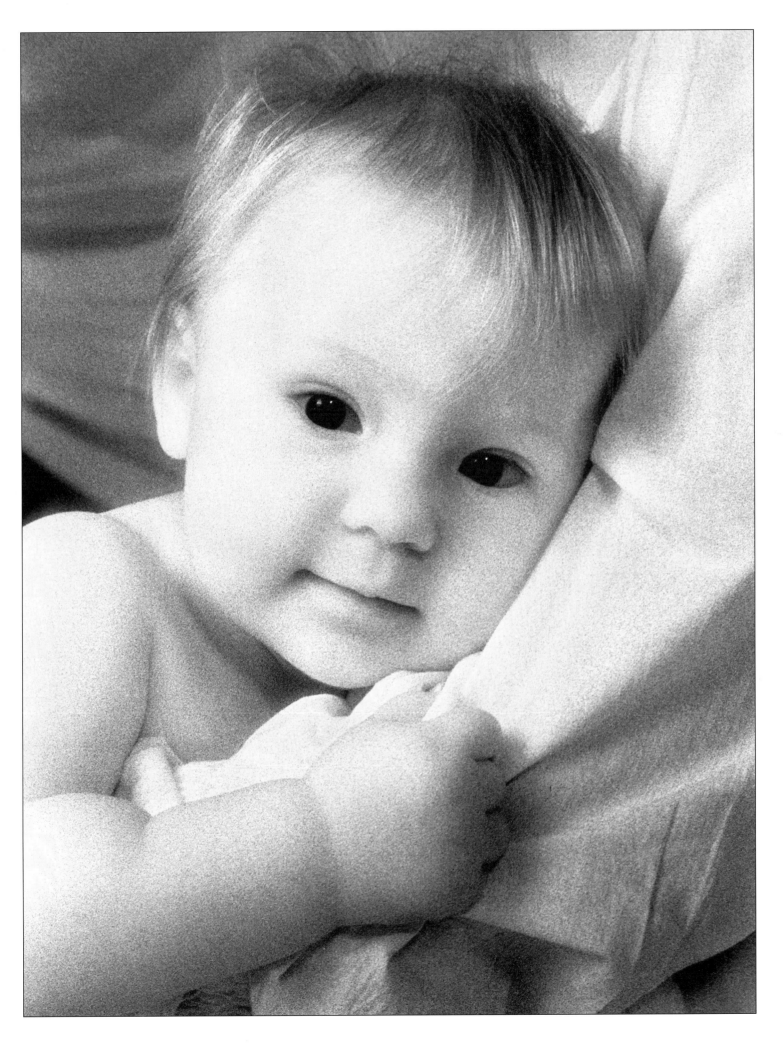

Experimentation

☐ Trying Something New

I'm always using new things for backgrounds in my studio. I was experimenting with an ivory colored sheer and regular tricot fabric to see how to drape it to get pleasing compositions when I took this shot. The model, Mary, was wearing an old dress of her mother's that was also ivory. The shot looked pretty neat with the sheer fabric covering the chair in the bottom left corner, with its lines leading into her arm, and then the same sheer fabric leading from her other elbow upwards out of the photograph. The background piece of regular tricot was held on a crossbar and clamped to give it visually pleasing folds.

☐ Spontaneity

It occurred to me to also do a shot in infrared in order to see how the new background would reproduce. Then I remembered the mask and beads I had purchased in New Orleans several weeks earlier, and had the model put them on. To complete the composition, I had her lift the hem of the dress, creating more fabric folds, and adding to the feeling of mystery of the overall photograph.

☐ Technical Info

The light sources here were a 4x6 softbox with a grid hair light, an umbrella fill, and a background with just enough intensity to keep the shadow caused by the main light off the background.

☐ Flattering Pose

TIP: To give a more slimming appearance to a model, keep a small gap between the subject's body and arm, much like we have here between her waist and left arm.

"... give a more slimming appearance..."

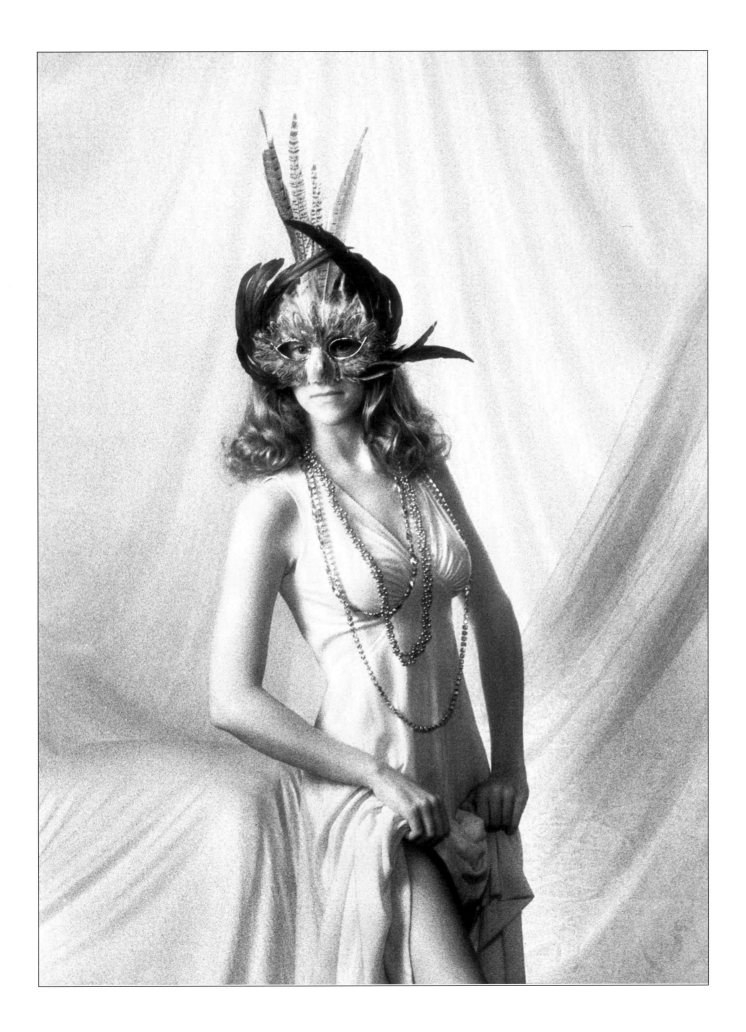

Small Subject

☐ Exploration

When not shooting images, sometimes I travel around my area looking for possible areas for future photography. When I came upon this old truck up on blocks by this barn being used for hay storage, I knew that I had stumbled across a very interesting location.

☐ Posing

When the client in this photo was in my studio, she wore the country dress you see here for her senior portraits. I knew when I saw it that it was the perfect outfit for the location that I'd found. I had her wear sunglasses when this image was taken, because the sun had not yet gone below the horizon, and I wanted her to be able to look in that direction and still be comfortable. I helped her up on to the truck, and she stood upon the body frame. The wind was luckily blowing into her face, so her hair blew away from her face.

☐ Composition

I adjusted my camera height so the horizon line intersected with where her right hand was posed on her hip. This allowed for the upper part of her body to be seen prominently against the sky. A plain blue sky would have photographed black, and in this case would not have been as effective as the white design caused by the clouds. Due to the spotlight effect of the sun on her and because the exposure was based on the light on her, the barn became a silhouette. This gives us just a nice shape with no detail which, in this case, would have been distracting from the subject.

☐ Consult with Clients

If you like to shoot this type of environmental portrait where the subject is quite small, be sure to include some samples to show during your consultation time. Quite often the client will express her liking for this style. On the other hand, she might say something like "Why can't you see the subject?" In that case, you know to not attempt to shoot something like this for her. The client is always right, after all.

"The client is always right, after all."

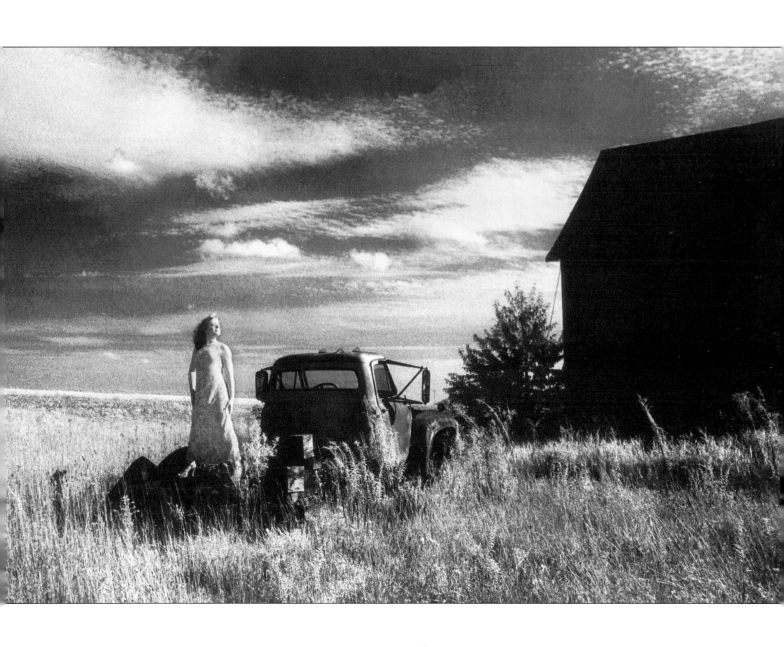

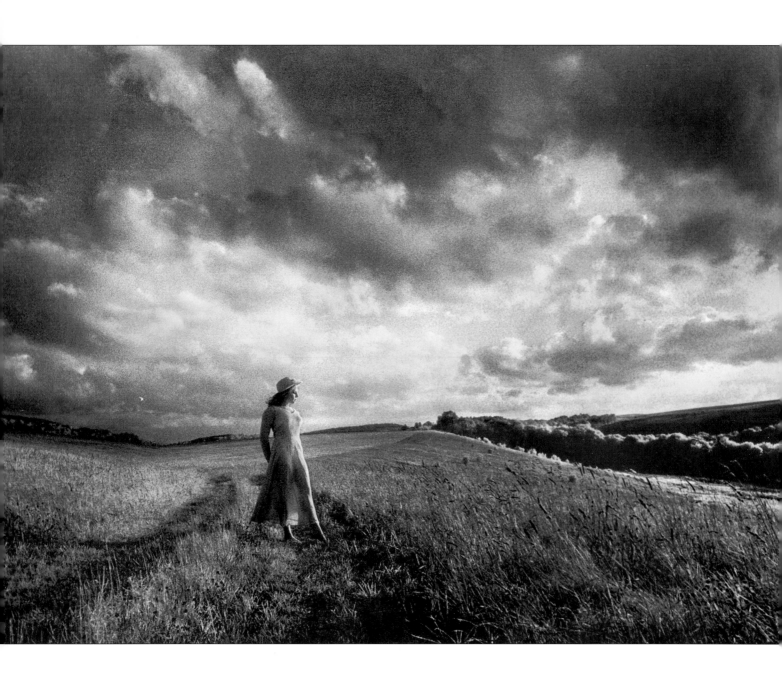

☐ Composition and Posing

A country dress and hat fit so many places in my area. I chose this location because the wind usually blows up across the hill, and I knew it would blow the long flowing dress behind the client. I stood her in one of the tracks in the road, which acts as a leading line into the photograph. The camera angle was adjusted so that the horizon line was below her shoulders and the attention was given to her face and upper body. The pose is simple, with her hands crossed behind her back, and the sliver of light coming through the bend in her elbow defining her waistline. Her eyes could have looked up into the sky or downward into the area in front of her. It was a simple choice as to which to use, really, since every time she tilted her head up, the hat blew off from the wind. The sun setting to the right of the image caused the right sky area to be brighter, so the sky was burned in while printing to bring detail to the clouds.

☐ Digital Manipulation

The horizon line of the hill on the left side originally went down off the edge of the photo, but that didn't allow the eye to easily enter the photograph. To correct this, the image was scanned and manipulated so that the horizon line came in higher, leading the eye in and downward towards the subject.

☐ Painting on the Print

The final print was made as an 8x10 on Kodak Ektalure G (a warm-toned black and white fiber paper). Oil paints were then added to make the sky a combination of blues, pinks and yellows. The client's dress was tinted a soft pink color to coordinate with the sky. The grass and trees were painted shades of greens with touches of heavier oil in colors of pink, yellow and blue to simulate flowers in the grass. The photograph was matted to an 11x14 size, and then placed in a delicate old fashioned gold frame. The end product was a small but dramatic piece for a high school portrait.

"... the attention was given to her face and upper body."

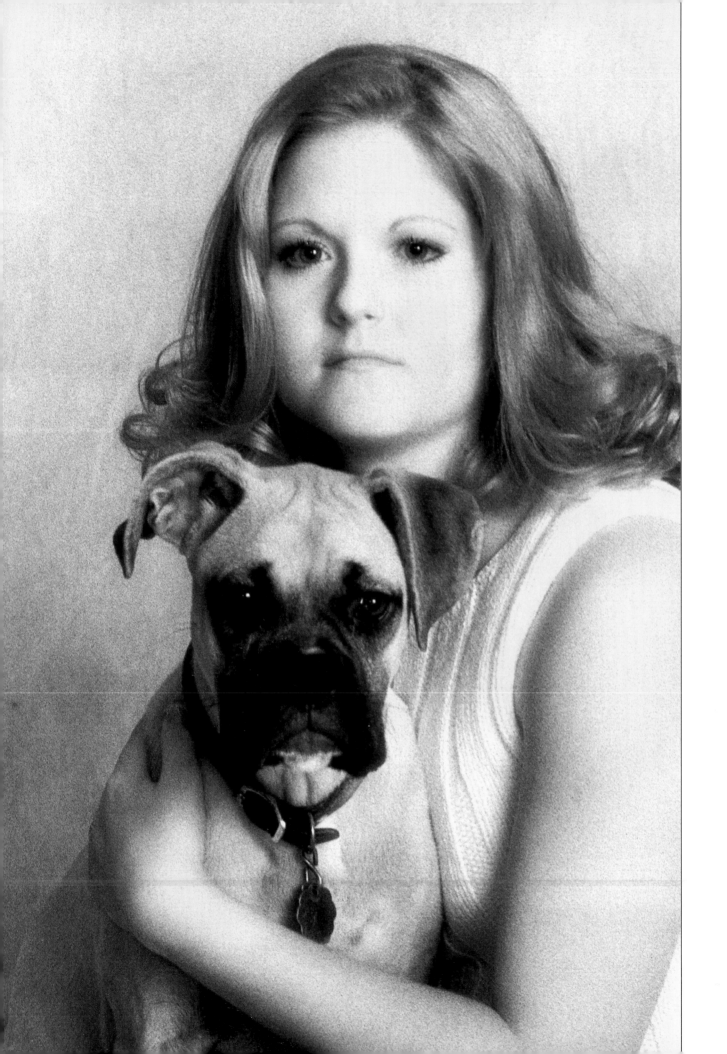

☐ Story Behind the Photo

After photographing scenics and people in infrared, I began to wonder what animals would look like as well. When this high school senior brought her boxer in with her for a few shots, I thought this would be a good time to find out. He had unusual coloring and shading, and I wanted to see if infrared would blend or record the delicate tones of the shading.

☐ Technical Info

I used a 4x6 softbox as a main light and added a fill and hair light, then shot against a light brown muslin background. I myself barked at the dog in order to get his attention, and his response (ears perked and staring at me) was the image I captured here. I was surprised to see that the subtleties of tones were present in the final image.

☐ Infrared as Art

As is very often the case when shooting a studio portrait against a flat background, the only major difference between an infrared image and a traditional black and white is that with infrared, your final image is lighter and has a more pastel look to it. If this is the sort of image you want to convey in the finished print, then infrared is the way to go!

☐ Ask the Client

Will I photograph more animals in infrared? Of course! Experimentation only leads to better and better photographs. However, I do think that most people prefer their favorite pet or animal to be photographed with color film, for a more "realistic" record of it. Always be sure to check with your client beforehand, and if in doubt, backup your infrared frames with shots in color or black and white as well. When it comes to a portrait sitting, it's better to be safe than to be sorry.

"Experimentation only leads to better and better photographs."

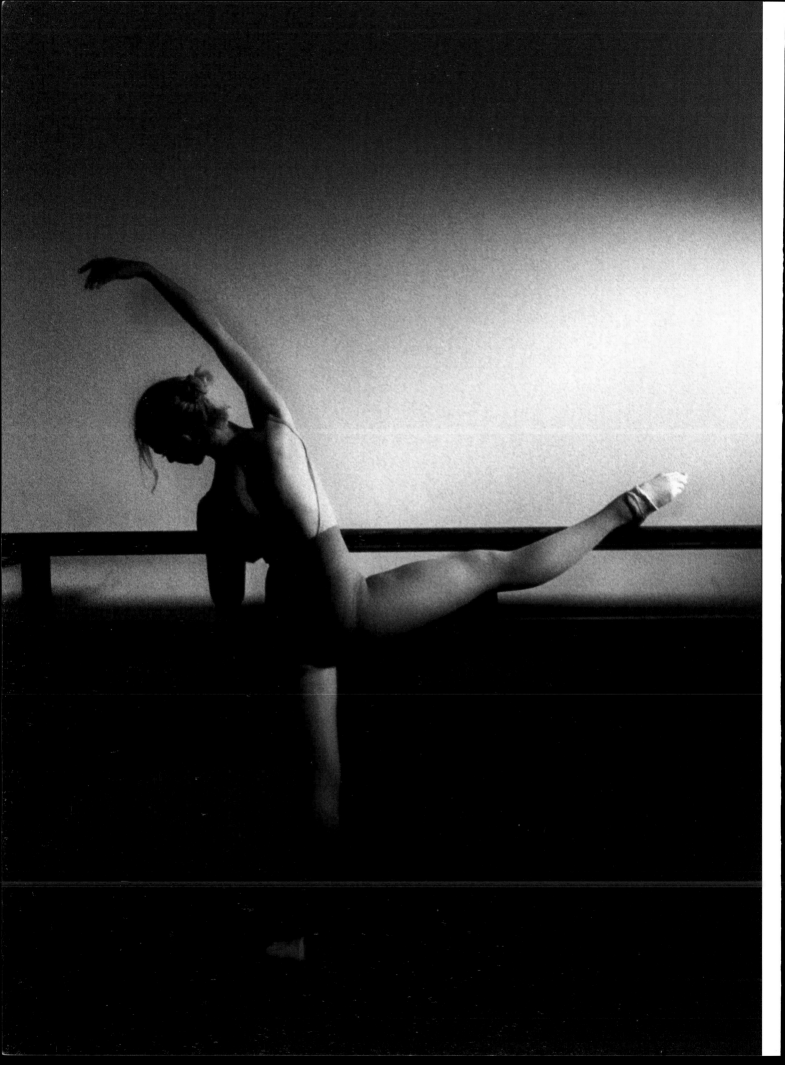

☐ Composition

The young lady here loves to dance, so it was quite appropriate for me to go to the dance studio where she takes lessons for this portrait. Scheduled at a time when there were no lessons being given, I set up and asked her to show me what warm-up exercises she would usually do using the rail. When she came to this particular one, I knew it was perfect for what I had in mind. The biggest difficulty proved to be how to illuminate the subject so the toes of the foot closest to the light source didn't get too bright, and the left foot and leg didn't get so dark as to blend into the dark carpet that covered the lower wall. Once we had the light set to do that, I refined the pose so that the highlight would form across her shoulder blade area, giving her back nice definition. A slight turn of her body to her left, and it would be gone, leaving a totally dark and featureless back, which would not have been nearly as nice. The final stark image suggests the many lonely hours the ballerina spends by herself to perfect her technique.

☐ Clothing in Infrared

I counted on the infrared film here to lighten her black leggings into a lighter tone, which helped to provide separation of the subject from the background. Experience using infrared will allow you to more easily anticipate what tones you can expect throughout an image, and how best to exploit them to your compositional advantage.

☐ Lighting the Subject

A single strobe with it's standard six inch reflector bowl was used as this portrait's only light source. The drama given by the harsh shadows helps the tone of the ballet rail against the white wall to not be as noticeable. The room wasn't very large, so a certain amount of fill light bounced back into the subject off of the surrounding white walls.

"I counted on the infrared film here to lighten her black leggings..."

Advantages of Infrared

☐ Story Behind the Photo

The reason for this portrait was specifically to show off this high school senior's long blonde hair. Her mother wanted a photo which highlighted the hair, and I tried to oblige her. I envisioned the pose, and wanted to make it look comfortable and relaxed, so doing it outside seemed to make more sense than rigging it up in the studio.

☐ Lighting and Posing

The main light source came from behind the subject, giving the rim light, due to the fact that large trees in front of the model allowed some (but not overpowering) fill light on her. If her face had been looking directly at the camera, the eyes and face would be darkened considerably. However, tilting her head back allowed the hair to hang freely and luxuriously behind her, and the light delicately illuminated her face. Her left foot rests on the right ankle so we purposely can see both ankles and feet, and the toes of her right foot are extended, making the leg look longer.

"The infrared... has more of a dreamy quality to it..."

☐ Composition

I photographed her from a small stepladder, so that the camera angle would be such that the highlight from the leaves of the tree in the background would be just above her upturned face. I also made certain that both her arms were visible as they lead back into the grass.

☐ Advantages of Infrared

I shot both color and infrared of this image, and I'm happy with the way they both came out. However, I'm a bit more partial to the infrared, because of all of the distinctive effects that you've learned about through this book so far. The infrared image seems softer, less harsh than the color image, and has more of a dreamy quality to it and seems to go best with images of this sort.

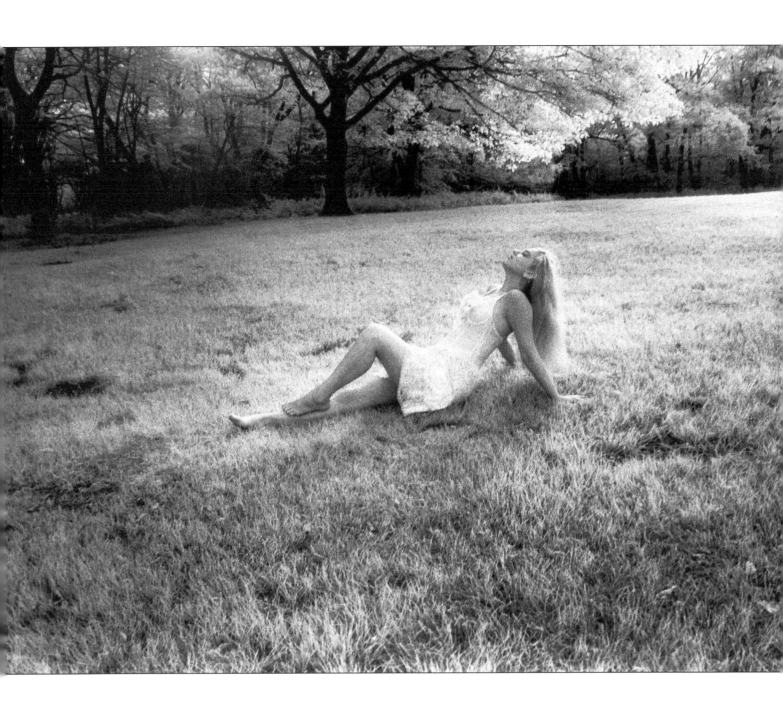

☐ Silhouettes

Silhouettes are fun to do with infrared film. With most foliage going into a lighter tone, you only need to find a way to keep the subjects in total shade to almost be guaranteed an interesting image.

☐ Composition

Here, the sunlight was illuminating the grass and trees while the couple was under a porch that received very little of that light. By exposing for the sunny area, the couple became nothing more than a silhouette. The hardest part was positioning the subjects so that little cracks of the background would show through specific areas, thus providing shape to the couple. With serious attention to this "placement" of light, where there was a shapeless mass of black, a romantic scene can now be discerned. The viewer can now see a man with long hair, leaning against a post, with his knee bent, kissing a woman. She in turn has her arms around his waist, is wearing fringed shorts, and has slightly-longer-than shoulder-length hair. In some ways, I would have liked to have seen more details down by their feet, but the darkness provides a good solid base, and since this image conveys so much already, I still consider it a successful portrait.

☐ Light Meter Reading

The set-up for this image is the same in infrared as it would be in color or black and white. When you want to create a silhouette, be sure to take your light meter readings from the bright background, and not the subject matter or models themselves. Don't forget about bracketing, either! Again, film is cheap, but memories are priceless.

"Don't forget about bracketing, either!"

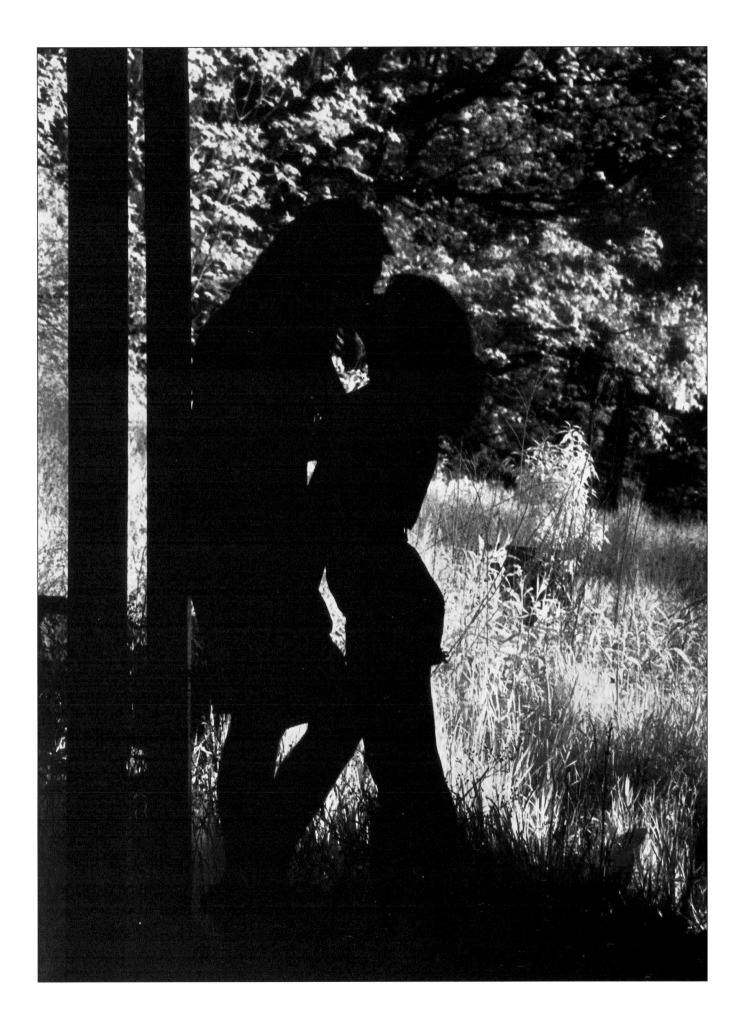

□ Composition

This is another high school portrait photographed in my outdoor studio, and I just love the way the infrared film shows the width of the individual blades of grass. We see the wider blades in the foreground and then the taller but narrower grasses in the background. The sunlight coming through the trees spotlights her face and arms as well as the background grass. There is enough natural light acting as a fill light to keep detail in our subject. The arms behind the head (as well as the head itself) are tilted back, which combined with the closed eyes, give the image a feeling of relaxation. The camera height was such that the grasses in the background stayed below her face, and that her face is framed by the darker wooded area in the far background. Our eyes are drawn to the area of greatest contrast, which is the area of the bright grass and her face with the dark woods behind it. This makes it easy for our attention to stay on the model's face.

□ Triangles in Composition

Triangles play an important role in this photograph: in the bottom left corner, there appears to be a triangular shape to the grass that goes back to her feet; each of her arms behind her head form triangles of their own; her leg pose makes another triangle; the V of her shirt collar; and the triangle of light on the shadow side of her face adds the final triangle. Altogether, six triangles enhance this seemingly simple portrait.

"Triangles play an important role in this photograph..."

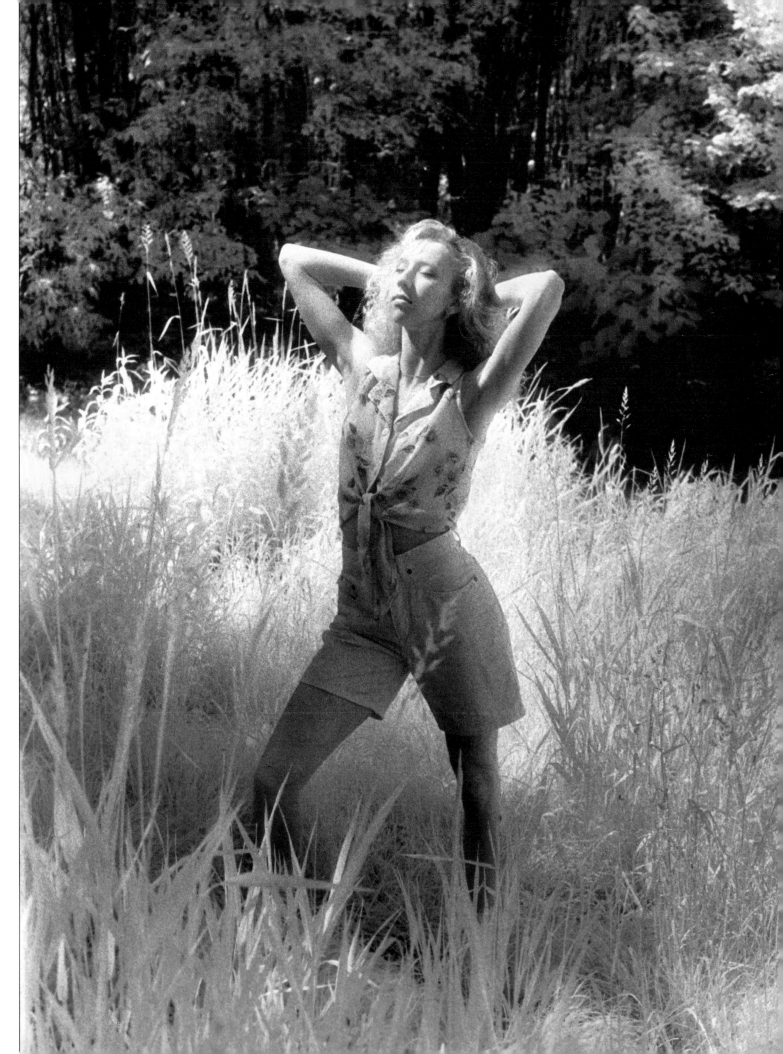

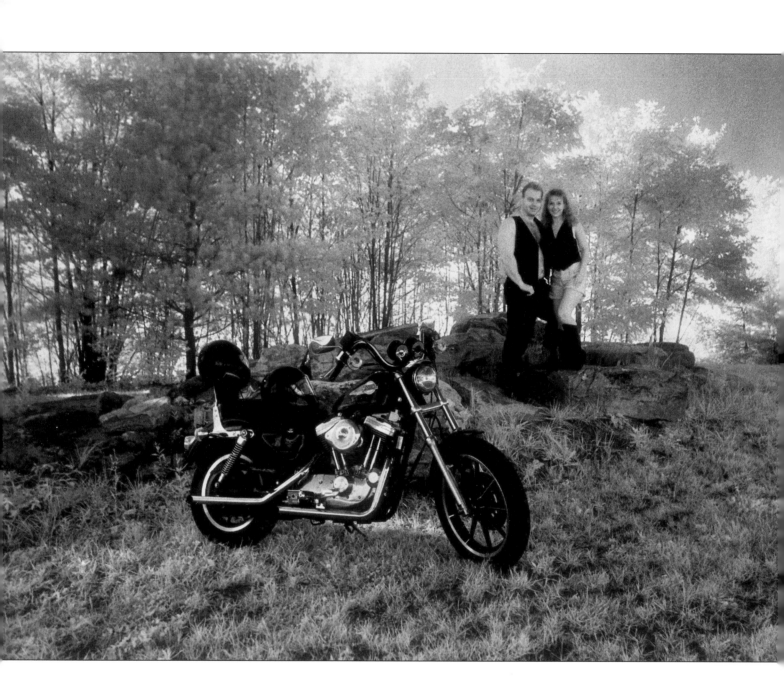

"... reach the fullest potential that you can with infrared."

☐ Image Evaluation

You need to ask yourself when you're about to take a photo in infrared whether or not the image is something that is going to be compositionally improved by the use of this special film. Again, you need to work on your pre-visualization skills. Until you reach a point where you can look at a scene and have a fairly good idea what sort of effects are going to be taking place, you'll not reach the fullest potential that you can reach with infrared.

☐ Infrared vs. Traditional Black & White

This portrait of Mark and Michelle and their Harley-Davidson motorcycle is one that wouldn't have been as effective as an image if it hadn't been shot in infrared. Here, the bike really stands out nicely from the background – the chrome projects, and the details are very nice, much better than they would have been in color or in black and white. As for the couple, would they be as prominent in color or black and white? No, not at all. They would have blended into the foliage behind their heads, and been mostly dulled out and lost in the portrait. Here, however, they pop right out, and a pleasing portrait of a couple and the love of their life, their hog, is the result.

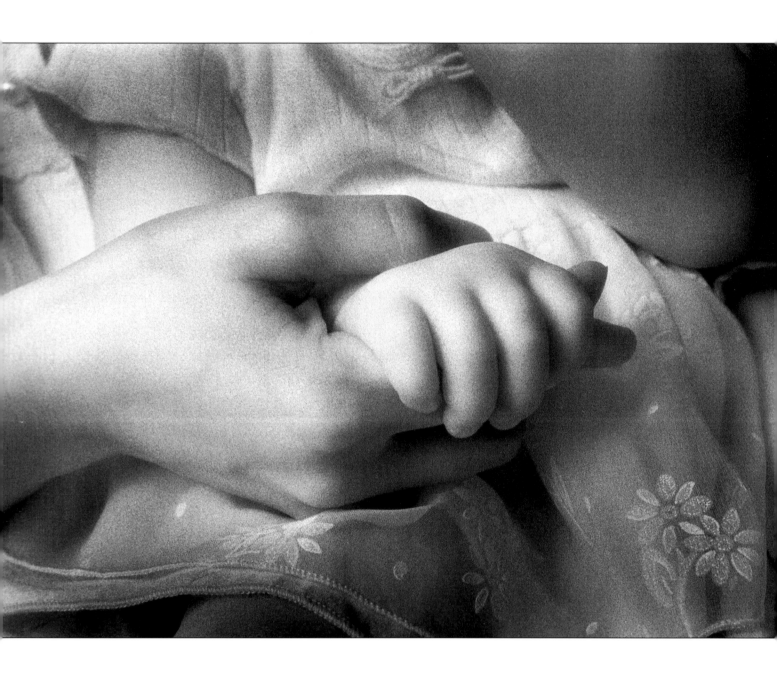

☐ Composition

Does a portrait of someone have to include the face? Perhaps a traditional one does, but this one tells us a great deal about our subjects without ever seeing their faces. We can see the delicate and yet firm way the larger hand holds the little one, who in turn holds on to the finger of the other for support and comfort. We see the dress of the small child with its delicate details and assume that it's a little girl. Next we see the arm in the upper right corner, which is at an angle, perhaps going to her face. Maybe she is sucking her thumb.

"The soft pastel quality of the infrared film... makes for a great fine art portrait."

☐ Advantages of Infrared

Obviously, we can get a glimpse into the simple relationship of this mother and daughter, which I photographed in my studio to show little more than their two hands. The soft pastel quality of the infrared film along with its pleasing grain structure makes for a great fine art portrait.

☐ Marketing

Here's a marketing tip for you: these kinds of close ups are great when selling a grouping of photographs, which can include more traditional styles of portraits as well. They add a great deal of impact to the overall series, and convey a great artistic feeling that elevates the final work to something even more special than it was to begin with.

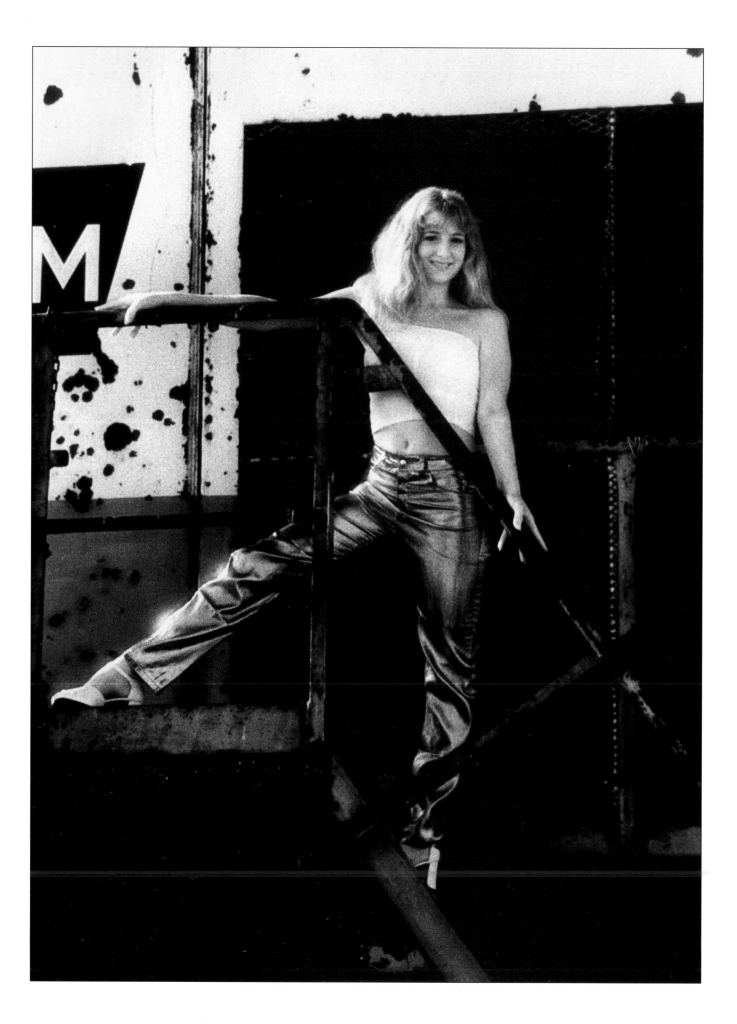

"I chose this area for the neat angles..."

Wild Subjects

So how do you photograph a subject wearing bright blue reflective slacks with high heels and a white crop top in the outdoors? Well, every photographer will have his own ideas. For me, I chose to rely upon one of my favorite backgrounds for use with infrared film: rusty metal. This happens to be an old piece of machinery that sits in a field.

Composition and Posing

I chose this area for the neat angles and then also posed the model's legs to provide a flattering angle for her. The sunlight comes in from the left side to illuminate her hair, and to create the highlight on her ankle. The open sky behind the camera is strong enough to keep nice detail in the outfit, and also provides illumination for the eyes. The subject pops off the background because of the lightness of her (made more apparent through the use of infrared film) juxtaposed against the darkness of the area on the machine, where the motor sits behind a metal screen. We end up with a fashion type portrait of this energetic young lady.

Posing and Composition

☐ Clothing Selection

With a vacation coming up in the Outer Banks of North Carolina, I purchased this brown dress and floppy hat thinking it might be a great outfit for my model to wear. The color of the sand at Jockey Ridge matched it perfectly, and the early morning light brought out the texture in both the hat and dress.

☐ Posing and Composition

By posing Beth on the shadow side of the small dune, the diagonal line leads you right to her. Also helping out were the blades of grass that point to her. Keeping her slightly in front of the dune allowed the lighting to be uniform from head to toe. The camera height was adjusted to keep the horizon line of the hill right below her fingertips. I kept her head turned to the right, because when it was to the left the overall flow of the composition was broken up. By turning her upper torso, I was able to allow some light to catch her right elbow. Along with that, the physical separation between her arms and her body helped to define her shape.

☐ Lines and Clouds

I always liked this image, and it wasn't until much later on that I noticed the subtle compositional lines that the clouds form, leading the eye from the upper left corner downward to the model's head. The lighting here is strong enough to produce a shadow, yet the slightly overcast day keeps the contrast under control so that there is detail throughout the scene. This is a very big plus in communicating the peaceful feeling from this portrait. The final image was printed on a colored paper – sand colored, as you might have expected.

"This is a very big plus in communicating the peaceful feeling from this portrait."

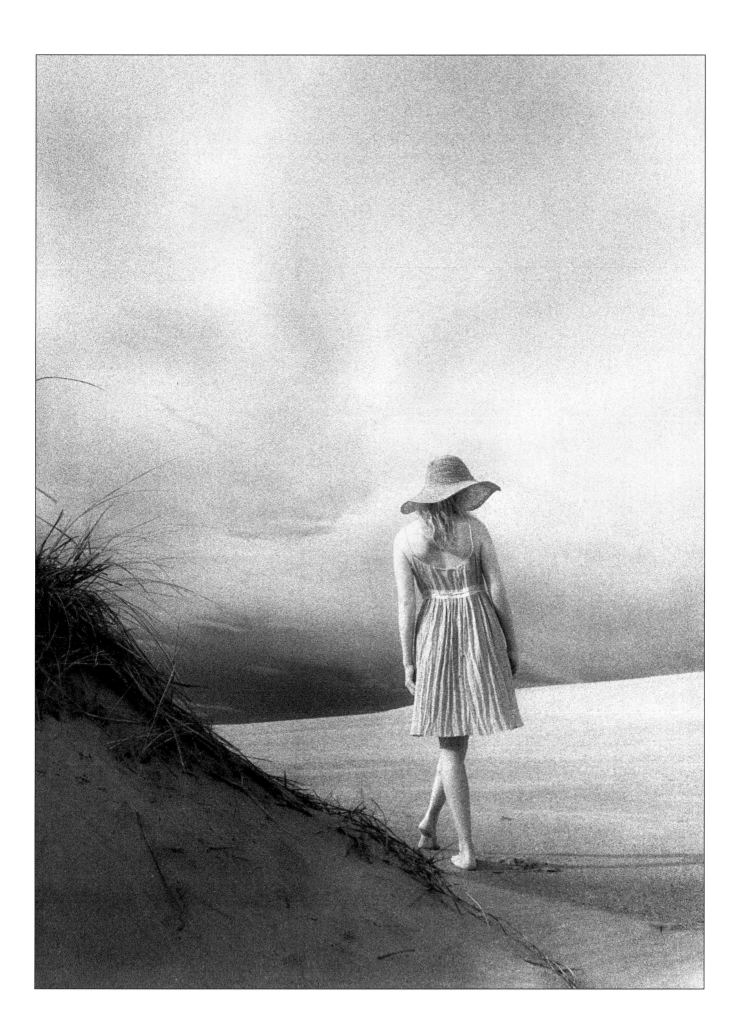

Exposure Range

☐ Pre-Bridal Session

For this bride's pre-bridal session, I went to the home where she grew up. The rear of the house caught my attention, both for the late evening lighting and also for the fact that she was to be married on the porch area there. I walked back towards the pond, which is just included in the left side of the image, to see if it would also make a nice place for a shot. After checking it out, I turned to look back at the house and saw the picnic table and benches, and the leading line of the white fence coming in from the left. I decided to place her between the table and house in the background. The camera height was set so that her head was just above the treeline behind her. However, I didn't want to set it too tall, wanting to keep it fitting into the inferred diagonal line that starts at the top of the trees on the left, slants towards the top of the trees, and then finishes up at the house. The somewhat low angle made her look tall and regal, and also enhanced the dress that she herself had designed.

☐ Exposure Range

Because of the range of exposure (the bride was in shadow, while bright sunlight was on the trees, and the bright sky behind her), the exposure was based on the light illuminating her. The brighter areas had to be burned in when printing in order to make a pleasing tonal range.

"... the exposure was based on the light illuminating her."

☐ Painting the Image

In the final image, light oil paints were added to the sky, table, benches, grass, trees and house, in yellows, pinks, blues and greens. In fact, only the bride was left unpainted, which gave a very unique presentation indeed.

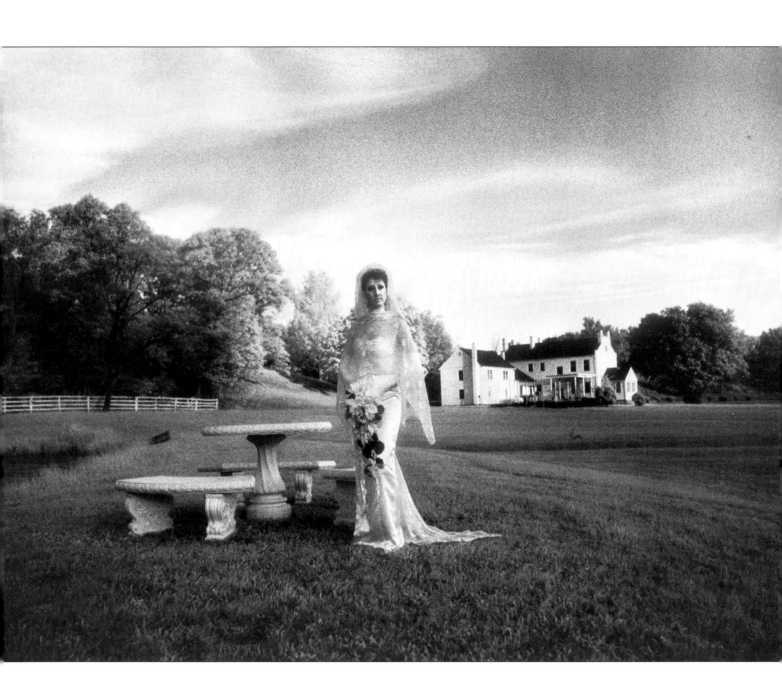

Leading the Eye

☐ Composition

Parents help to guide children. In this image, a mother is portrayed helping to lead her children. The mother is shown as a strong person. Her body is the only one breaking above the horizon line, and so visually, the eye comes to her first. The white hat she is wearing only helps in this. The two children are noticed following this. The one on the right seems somewhat apprehensive about going ahead. While the viewer doesn't see their faces, the photo captures their personalities, making it a true portrait.

☐ Visualizing Skies

By using a wide-angle lens, many clouds are included in the image, clouds made much stronger and more pleasing to the eye through the use of infrared film to darken up the sky. If you look, both the clouds on the left and right sides of the image seem to flow towards the center, where our subjects are placed. Remember when composing an image such as this to view it through the 25A filter, so you can get the best feel for how the finished product is going to look.

☐ Leading the Eye

The triangular wedge of trees in the distance adds dimension to the image. While the grass in the field area is turning quite light because of the infrared, the trees maintain some dark areas as well as a few light tones. The horizon line of the field and trees, much like the clouds, also leads the viewer to the main subject, the mother and her children.

☐ Roads and the Viewer

Roads are always great places to pose people. They allow for stories to be told with very little effort. The viewer gets the impression that the people are on a journey to somewhere, which leads to all sorts of questions about destination in the viewer's mind, drawing him into your portrait that much more.

"Roads are always great places to put people."

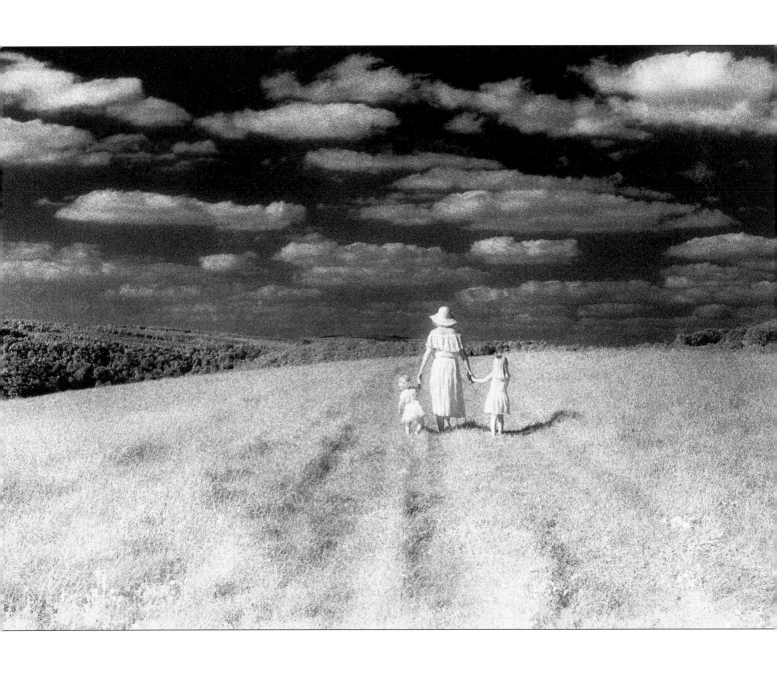

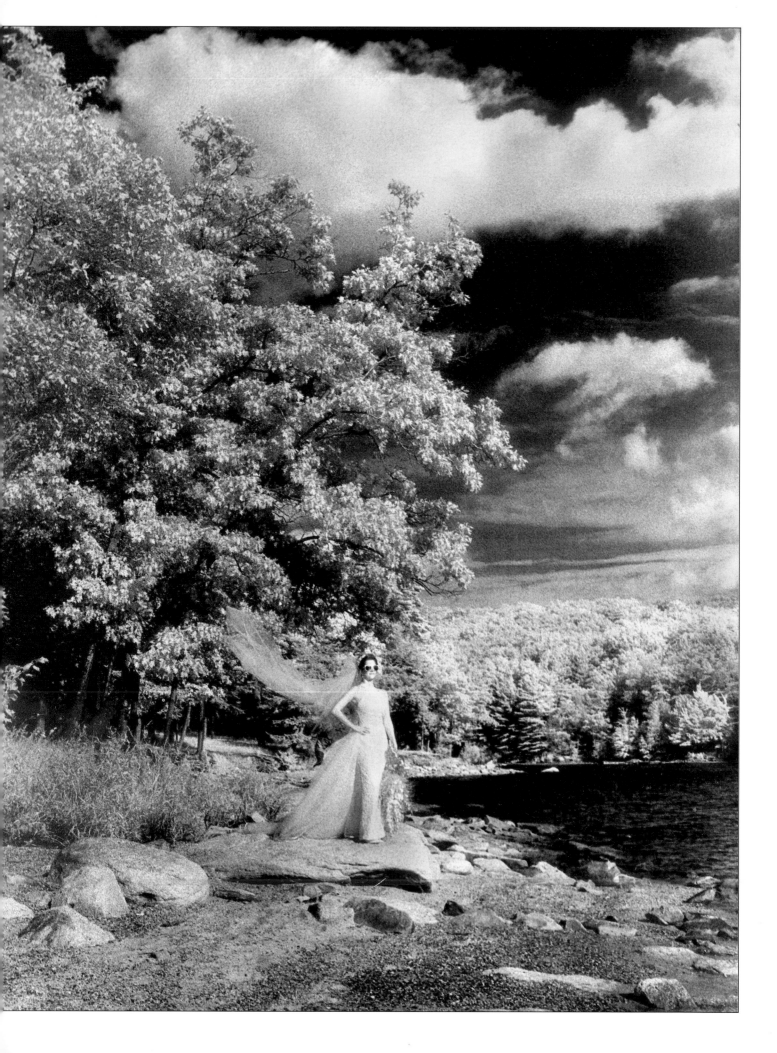

☐ Creative Couple Sessions

This is a portrait taken during what I call a "Creative Couple Session." It's a session done on a day other than the wedding. These sessions are great, because they allow me to have the creative freedom to get some great portraits of a bride and groom that wouldn't otherwise happen because of time constraints.

☐ Composition

When we got to this spot, I knew instantly what I wanted to happen in the photo. I knew that the viewer's eyes would come in through the trees from one side side, so I placed the bride at the spot where she would become the focal point of the image. Her pose is proud, with the elbows out from the body to keep her waist looking slim, and looks sort of funky when you include her sunglasses in the overall composition (the glasses also served the functional purpose of keeping her from going blind while staring at the sun). She's facing the direction she is because that's where the wind was coming from, and I wanted to have the veil blowing out behind her. My lovely wife and assistant was behind the model and tossed the veil up in the air, letting the wind catch it, and then she hid behind the bride so I could snap the photo. Ah, the life of an assistant!

☐ Romance of Infrared

There's a lightness and airiness to this image that I really like, and it's something that you can expect to see a great deal of once you are actively shooting infrared on a regular basis. It's a romance that you just can't get with any other type of film.

"... a romance you can't get with other film..."

87

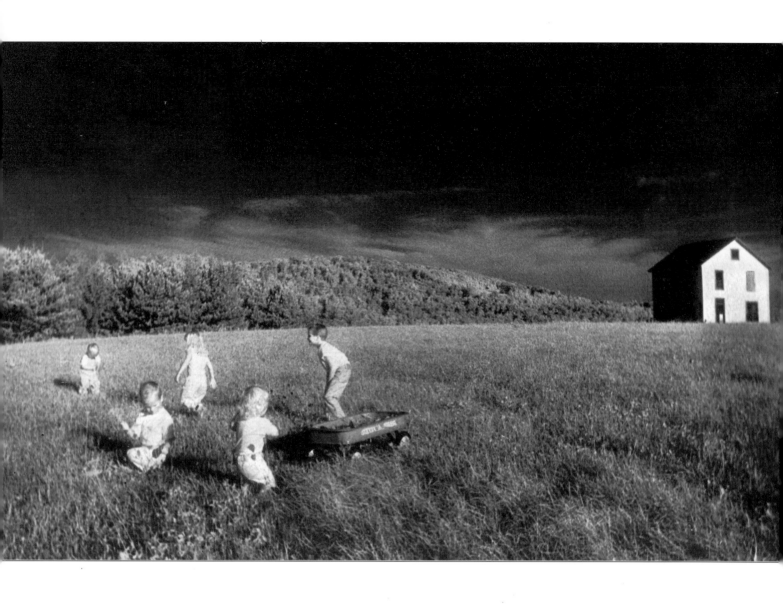

☐ Story Behind the Image

I remember the day I spoke to the client for this image on the phone for the first time. She wanted a photograph of five children to give to their grandparents for Christmas. The youngest was two, and the oldest was seven. It sounded like a photographer's nightmare to me, until she let me know that those involved had all agreed that they wanted a black and white image and that they would allow me complete creative control over the image, as long as the portrait was shot outdoors. What photographer could pass up something like that?

☐ Photojournalism

To simplify clothing, we had the children wear jeans and white t-shirts. Not only was it nice for the photo, but it was something everyone had and was comfortable wearing. The day of the shoot, when I first met the children, I realized that posing was out of the question, and so decided to approach the shoot in a photojournalistic style. I wanted to capture their five distinct personalities, not force them to stand still and smile for the camera.

☐ Props

I had packed a red wagon I keep as a prop for this shoot, and set it out in the field. I instructed the kids to treat the wagon as a flower basket, and for them to fill it with all the flowers that they could find. While they were busy picking flowers to fill the wagon, I stood on a small stepladder, shooting downward with a wide-angle lens (which gave the kids a lot of room to roam). The kids were so energetic and active that I shot a lot of film from this location, and through luck and happenstance, the kids accidentally formed this circular composition.

☐ Advantages of Infrared

The infrared film gave the image a more "old world" image, a grainy and softer story-telling look than you would get with black and white film. The final image was printed through a top-of-paper texture screen (to give the image more grain texture) on a brown-toned color paper.

"The infrared film gave the image a more 'old-world' image..."

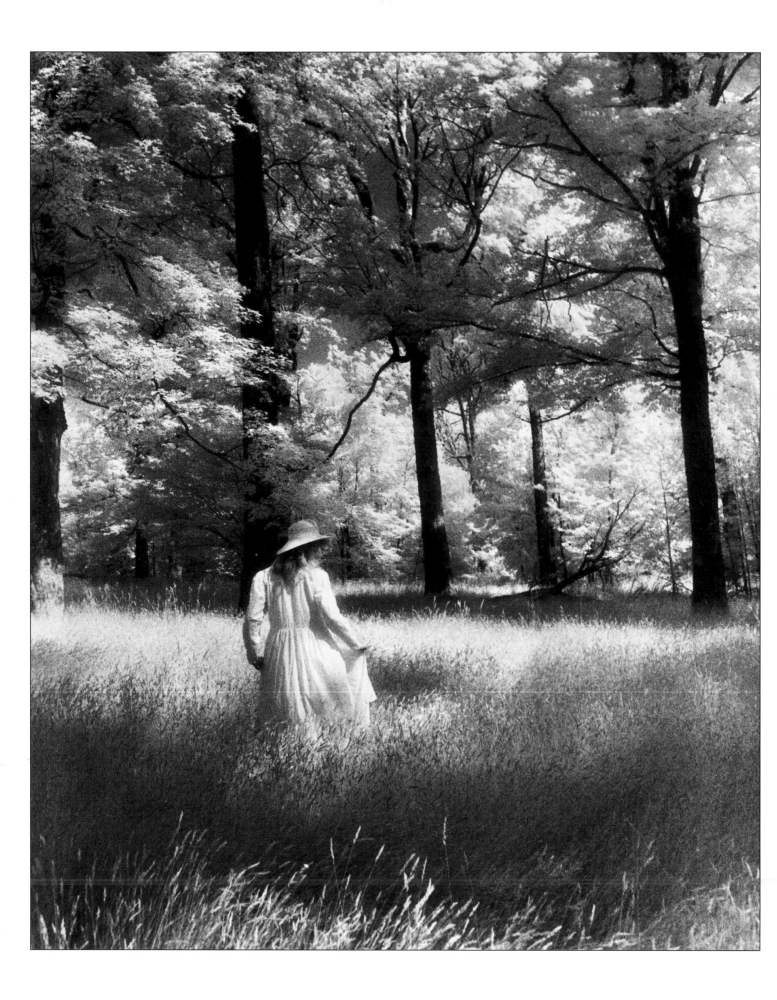

□ Location

Out in the country, we have picnic groves – areas which no one uses for anything other than nice, lovely afternoon picnics. When I saw this particular grove on this particular day, I knew instinctively that it would be a great place to shoot a portrait. The feeling of security and comfort that you get from looking at this grove of old trees was one that I wanted to capture on film.

□ Lighting

Notice how the light on the grass covers different areas in different intensities? I was also drawn to this spot for that reason, wanting to see how it would record in infrared (again, give in to your curiosity!). You get an idea here how different lighting situations can really give you different results in the final portrait.

□ Composition

Karen, the model, had a lovely outfit, and it fit into the country feel I was trying to capture. Her elbows are kept away from her waist to help keep her figure looking slim. I also had her turn her face away from the camera to instill a sense of mystery to her, raising more questions about her than are answered. Notice also that she is has less light on her than the surrounding area. This is intentional. I didn't want her to be blown out in the final image (don't forget to consider such things when you are setting up your composition).

"Give in to your curiosity!"

More "Creative Couples"

☐ Client's Choice

This is another portrait from a "Creative Couple Session," on a hill which is a favorite of mine. The couple knew that they wanted something in black and white, and decided that they really wanted to go for something different and have an infrared portrait.

☐ Composition

I shot this in the fall, so there wasn't a great deal of infrared reflection going on here (the best time for that "infrared" look is in the spring, when the plants are fresh). I had the couple try a number of different poses here: walking together; hand-in-hand, etc. This shot was the most pleasing of them all. I had the bride hold her dress up and walk alongside the groom, who had the honor of holding the bouquet in this shot. The bouquet was held at the horizon line, because I felt that there it would have the most attention paid to it by a viewer, who would be wondering why the groom was holding it, and not the bride (for the record, it's because the bride couldn't hold it and her dress at the same time).

☐ Why Infrared?

In color, this photo wouldn't be as interesting. It was a fairly overcast day, with a few spots of sunlight here and there, and the scene had a very dark and muted air to it, in color at least. In infrared though, the background is somewhat muted, and looks much nicer than color. The clouds get a little more life than they otherwise had, and the portrait is improved immensely.

"In color, this photo wouldn't be as interesting."

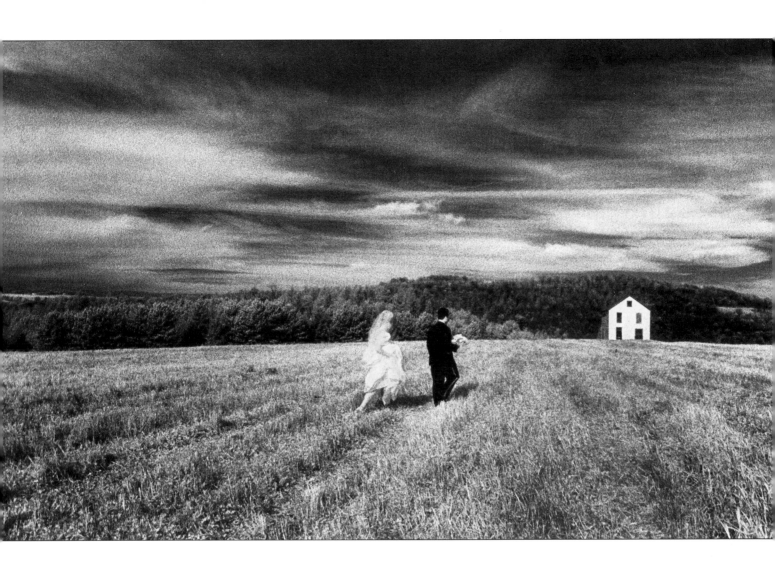

Unusual Machinery

☐ What Is It?

This photo is from a high school portrait session, and was shot at an unused piece of machinery – a drag line. It was sitting idle in the bright sun, and there was just something about it that demanded attention. I liked the way the grass was growing up in the bucket, and decided to shoot it and the chain in some fashion.

☐ Composition

There is a sense of balance to this photo that I like. The foreground grass matches nicely with the background clouds, and there's a wonderful triangle formed from the links of the chain. I shot the client from a lower position in order to make her more tall and more prominent. This meant she wouldn't be overwhelmed by the wonderful piece of machinery that surrounds her and lose out on being the subject of the photo.

☐ Infrared Equals Interest

This photo has all the trademarks of infrared: the white foliage; the brilliant clouds against a dark sky; the soft and light skin tones. All in all, this portrait is simply more interesting for the infrared effect than it would otherwise be in color or black and white.

"This photo has all the trademarks of infrared..."

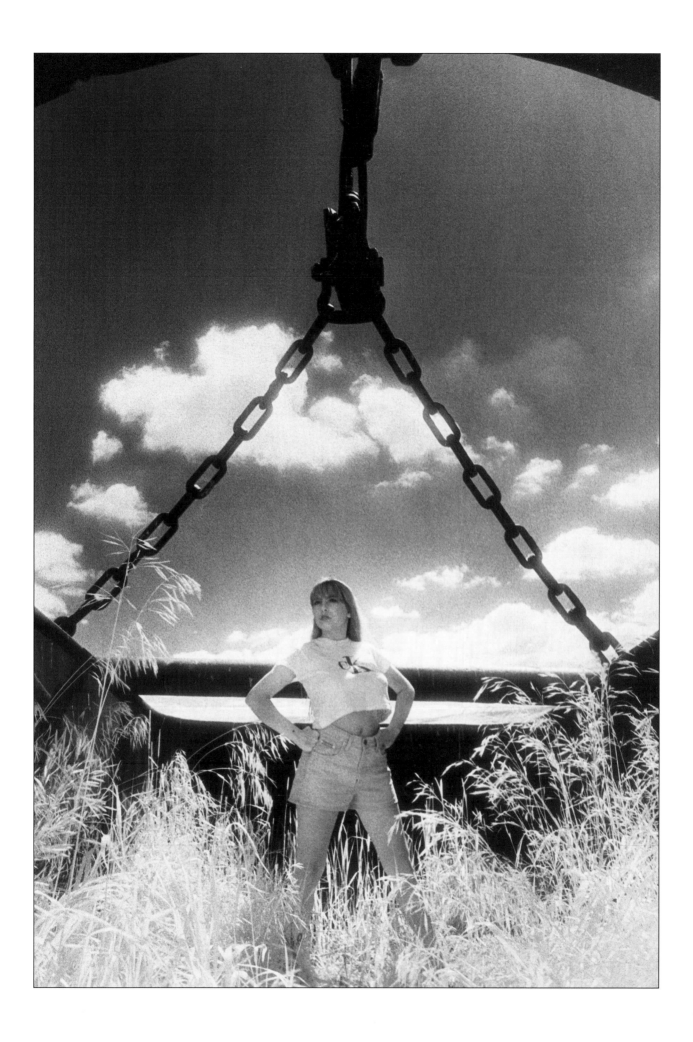

Contrast and Infrared

☐ Location

This portrait was taken at a local train station, at about 2p.m. on a bright and sunny day. The model is beneath an overhang of the building, so she isn't in the direct harsh sunlight. The building was at this time in a state of disrepair (although it's recently been cleaned up), and had a great deal of texture to it that I enjoyed.

☐ Color and Contrast

This building is wild when photographed in color: all bright red bricks and green from the paint on the door. I felt this would have been distracting for the image I had in mind, and so went with infrared to mute it all down a bit. I wanted to have an image which focused more on contrasts than bright and overwhelming color.

☐ Composition

Going with infrared allowed me to focus on the model herself rather than the colors of the scene. It gives a soft look to the building that matches the model's dress (the dress was an ivory color to begin with), and gives a very pleasing effect to her features.

☐ Flattering the Subject

The model had just returned from a vacation, and had a sunburn at this time. Infrared allowed for me to photograph her without that sunburn showing at all, which is another reason why color film would have been out of the question. You have to keep in mind that when you are shooting a portrait, it is your job to ensure that the model looks as good as you can make her look. This isn't the case with something you're doing for a purely artistic reason, of course, but with your clients, you'd do yourself a favor to take the effort to make them look as good as you can.

"Infrared allowed me to focus on the subjects rather than the colors..."

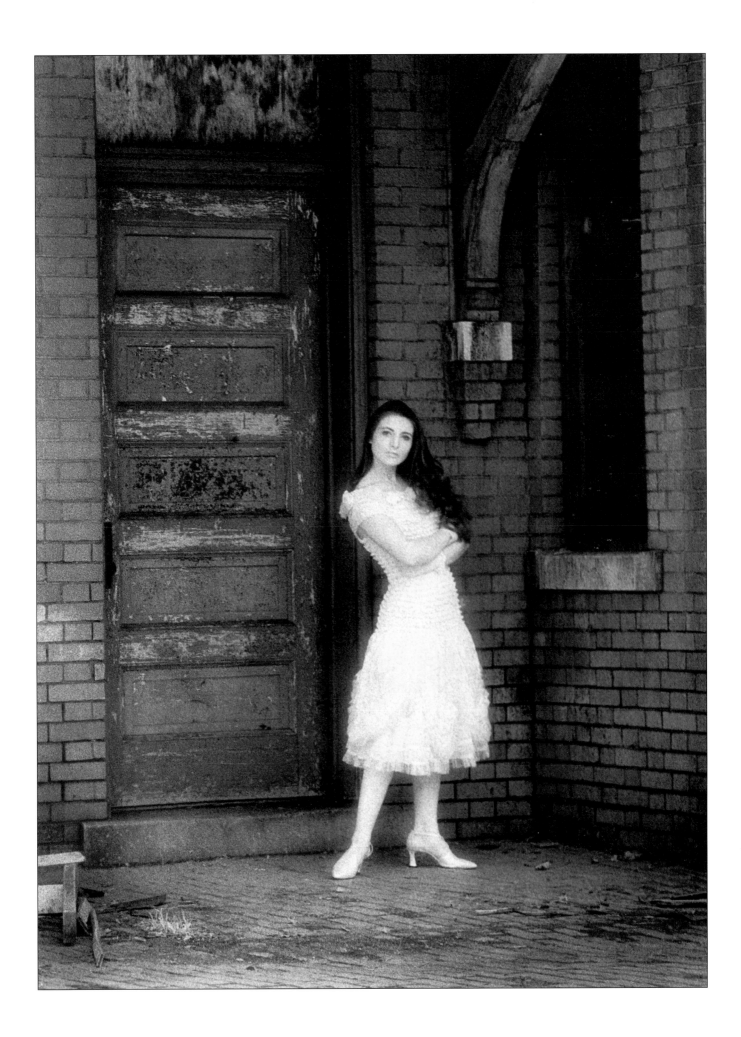

Consultation

This is another high school portrait, taken at my studio. This young man and his mother wanted to have some black and whites taken, and after looking at my consultation book, decided to try some infrared as well. Never forget to show your clients previous portraits you have taken, because you never know what sorts of images they will find most intriguing.

Concept and Lighting

This client was extremely proud of his physique, and so I wanted to use a pose that helped to show it off. I decided to have him remove his shirt and wear only the jacket, thus calling more attention to his chest. After having spoken to him, I knew he was a nice young man, so I didn't want to make the portrait overly moody, since that didn't appear to be his character. I think this portrait succeeds in that respect. It's a sexy image without being threatening (and my female clients always seem to comment on how good looking he is in it!). The lighting was from a medium-sized softbox and hair light.

Complexion and Infrared

Infrared can be extremely useful when shooting teenagers or those with less-than perfect complexions. The way infrared lightens the skin almost always helps to make minor acne or discolorations disappear, and I've yet to meet a subject who didn't appreciate the help!

"A sexy image without being threatening..."

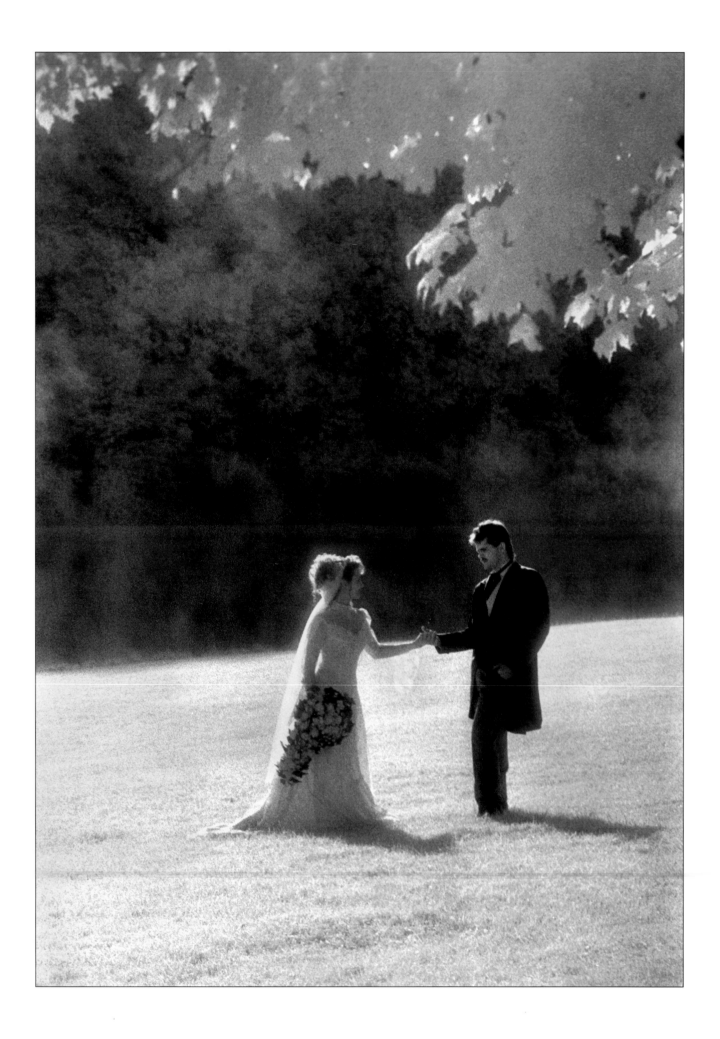

"... experiment with different subjects to see what happens to them in infrared..."

☐ **Fog and Infrared**

This is another portrait taken from a "Creative Couple Session." It's early morning in May, and there is a slight fog coming up off of the water in the background. This was my major reason for shooting the image in infrared – to see what the fog would look like. It adds a pleasant, dreamy quality to the portrait that I find very appealing, but I'd never have known it unless I tried it out. Remember to let yourself go and experiment with different subjects to see what happens to them in infrared.

☐ **Composition**

Pre-visualization was important to this portrait in order to keep the overall composition of the final image strong. I knew that the leaves at the top of the image would go light, and I wanted to have them mirror the grass at the bottom, so I needed to chose a camera angle which would allow for that. The background would stay dark, I knew, since there wasn't any sunlight hitting back there at this time of the day.

☐ **Posing**

I had the couple try a variety of poses, before choosing this one as the best for the scene. I had them hold hands, and adjusted the position in the frame until their hands were where you see them now – the best place to call attention to them. I instructed the bride to keep her bouquet down at her side, to make it less prominent in the photo (it was a gigantic bouquet! I was sure she would need help holding it up at the wedding the next day). Notice that I had her keep her elbow away from her waist, which has the desired slimming effect. Always keep in mind that it's your job to ensure that your clients look their absolute best!

□ Location

The model and I were driving off to do some outdoor work when I spotted this tunnel beneath a railroad track. I slammed on the brakes and drove over to it, because I could feel the potential for something truly interesting there. It was about thirty feet long, with leaky walls and chips in the cement throughout. It looked quite strong still, however, and so I sent my model down to the far end and into the bit of sunlight there.

□ Why Infrared?

Just from the colors at this scene (the hodge-podge of leaves, discoloration in the concrete, the brown dirt road running through the tunnel) I knew that I wanted to shoot in infrared so as to keep some sense of order to the scene. However, I also wanted to see just what infrared film was capable of. Would it be able to handle the wide range of tones in this scene? I bracketed my exposures and found the answer to my question. The infrared film looks beautiful, and it obviously is capable of handling a wide range of tones, from bright highlights down to the deepest blacks. I'm certain after shooting this image that infrared can handle anything I can throw at it.

"... infrared can handle anything..."

☐ Marketing

From a purely marketing standpoint, offering infrared portraits to your clients can be a financial plus for you. It's been my experience that the more upscale folks out there are the sort of people who would like something different from the norm for their portraits, and a great number of them find that infrared suits that desire quite well. It gives them a nice change from the typical sort of portrait that they've always had before.

☐ Posing a Romantic Portrait

The wife in this portrait called to let me know that the couple was going to be on vacation soon, and would like to have a portrait sitting done at that time (the man is a successful businessman, and doesn't have much free time for such activities during his normal life – the vacation was the best time for it). We shot this image on a porch, and I tried to ensure that it was a soft, romantic image that reflected the love that they have for one another. The infrared helps in this goal, as it automatically ups the romance level just by its very nature. The pose gives an additional level to the photo, showing them physically wrapped up into each other as they are emotionally as well.

☐ Clothing

I am very pleased with the way the sequins on her dress turned out, because I wasn't sure what would happen to them in infrared. They are the same shade of black in color as her dress and skirt, but since they weren't of the same material as the clothing, it wasn't possible to guess ahead of time what they'd be like in the finished product. I like the overall way they came out, though. They add a nice visual pattern which adds to the photo, and makes the image stronger.

☐ Skin and Infrared

Infrared is a good medium of choice for the portrait photographer when shooting the over-forty crowd, because of the pleasing effect it has on skin tone and quality. It helps to soften age lines and give the skin a more youthful, glowing appearance.

"... offering infrared portraits can be a financial plus..."

Eyes and Infrared

☐ Background

This is another high school portrait that I shot in my studio, against a pair of prop accordion doors that my wife, Esther, sponge-painted gold and brown to match a background for our color portraits. The doors look a bit splotchier here than they do in color, but I don't feel it distracted from the subject enough to really worry about.

☐ Eyes in Infrared

This young woman looks absolutely fantastic in infrared! I've mentioned before how some model's eyes work in infrared and some don't. Obviously, her eyes are some of the ones that do. There is a very high level of definition to them. The pupil is very clear, and you can see a nice highlight from the main-light as well. If you get a model with eyes that reproduce as well as hers, do anything within your power to keep her!

"... she looks absolutely fabulous in infrared!"

☐ Pose

This is a very peaceful pose. She is leaning back against the door, showing off her lovely hair to its fullest. The eye is drawn in towards her face, a result of all the lines in the image (in her shirt, in the doors in the background–the eyes travel in to the area where there are no lines). The infrared softens her skin and combines with the pose to give the image a very soft and romantic air.

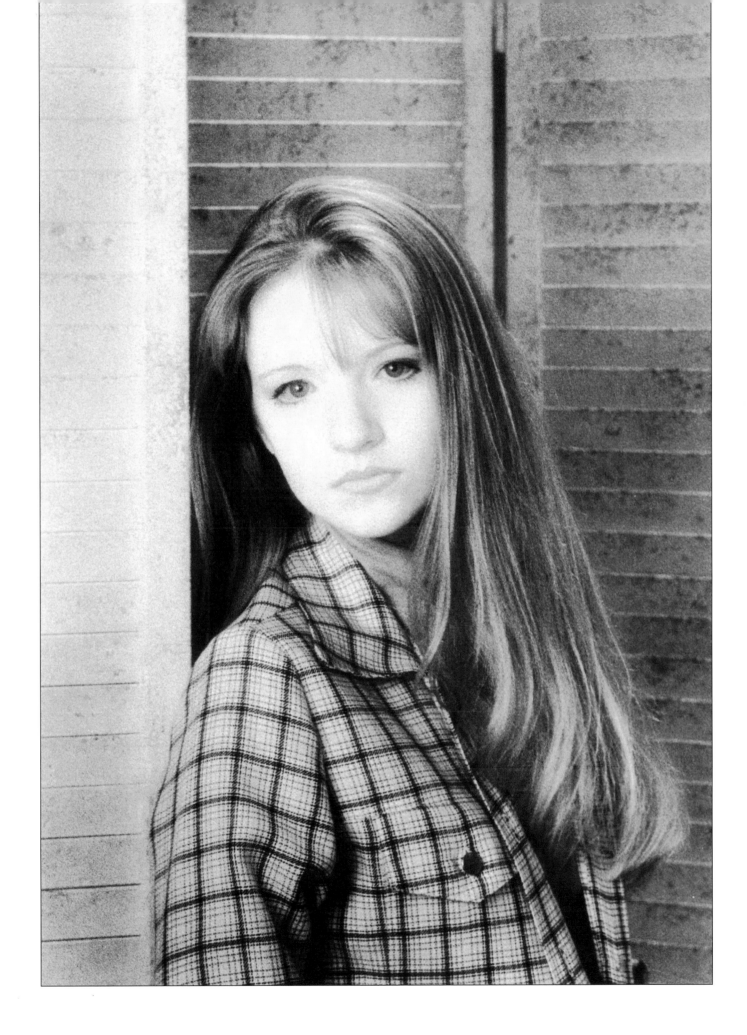

More Eyes

☐ Make-Up

Knowing how infrared whitens the skin, I had an idea of doing a headshot where the eyes would be the featured part of the subject. This studio portrait did just that. The beautician did a great job of using enough eye shadow, eyeliner and mascara. The lips were kept a light red, which kept the attention on the eyes (had a dark lipstick been used, the lips would have had more drama, which isn't necessarily bad, but it wouldn't have fit the look of this shot). The hair was styled for a loose curl look, and to avoid any distraction from clothing, we shot the model bare-shouldered.

☐ Technical Information

The main light is a strobe fired through a bed sheet, while the fill is a medium-sized soft box set one stop less than the main light. The film was also overexposed by one stop. Any greater exposure in this case would have started to flatten out the image.

☐ Eyes and Infrared

The success of this photograph is the expression in the eyes. Is it sexy or searching? Happy or sad? The slight cropping of the top of the model's head helps to keep your eye focused on her face, but the concept behind this portrait wouldn't have worked as well in color or black and white. It's the nature of infrared to call attention to the eyes in a close-up situation like this, and it does the job very well. Keep in mind, though, as I've said before, not everyone's eyes react to infrared in a pleasing fashion, so it's best to experiment before you bet the farm on the image coming out exactly like you had in mind.

"It's the nature of infrared to call attention to the eyes..."

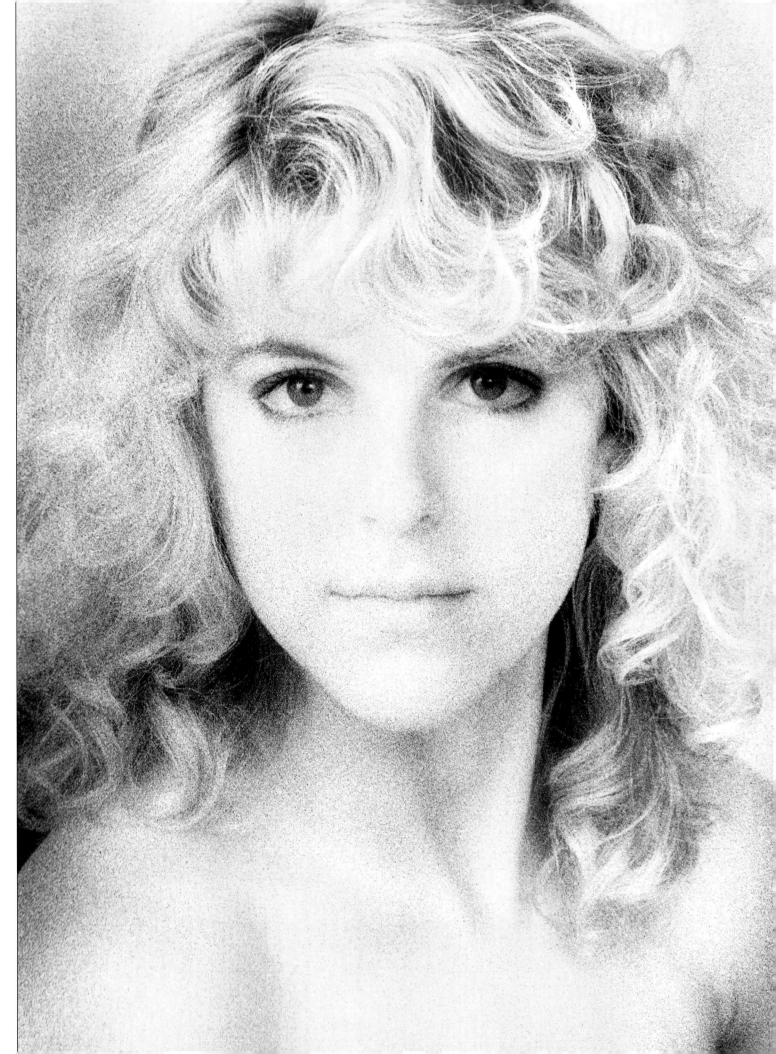

☐ The Mystique of Infrared

Infrared in this portrait only adds to the mystique of the image. The models' skin stands boldly out from the darkened bricks of the background, while there is still an overall softening effect which gives the image a pleasing sensuality that wouldn't be possible in straight black and white.

☐ Story Behind the Photo

Photographed while giving a seminar in New Orleans, this portrait of two models provides an intriguing story. After having been in New Orleans for several days, I was fascinated by all the ivy and fern-type plants that were hanging from the balconies and walls. Finding a wall with these plants just slightly higher than the subjects was perfect.

☐ Posing and Composition

I leaned the male model against the wall in a relaxed pose, and then brought the female in up against him. The viewer's eye starts at his hand, travels up to his face, comes over into hers, and then slides downward to her hand in her pocket. To express his character, I left his shirt off in order to show his nipple and navel rings. Her crop top also allows us to see her navel ring as well. The contrast of the white foliage against the brick wall mimics the design in her shirt. Normally, I would have tipped his head more towards hers, but I didn't, since they are not a romantically involved couple. I loved the way he looks out beyond the camera and she looks right in the lens. We were photographing in the shadow of the wall, so the main light was the open sky in front and to the left of the models.

"Infrared... adds to the mystique of the image."

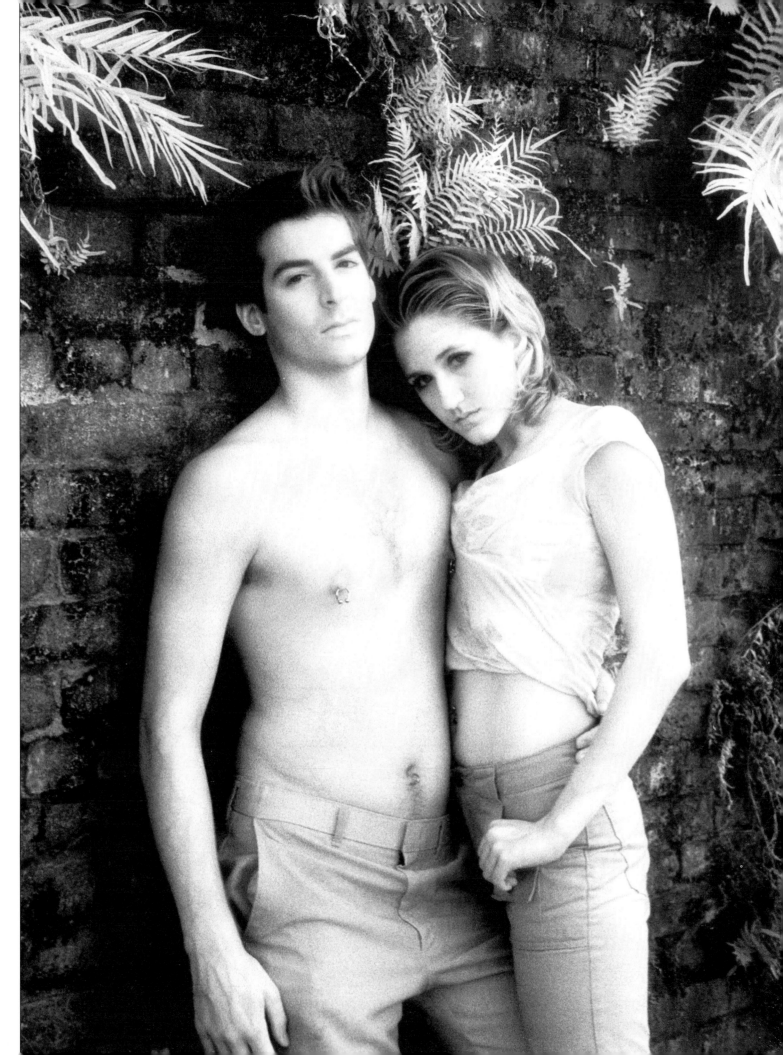

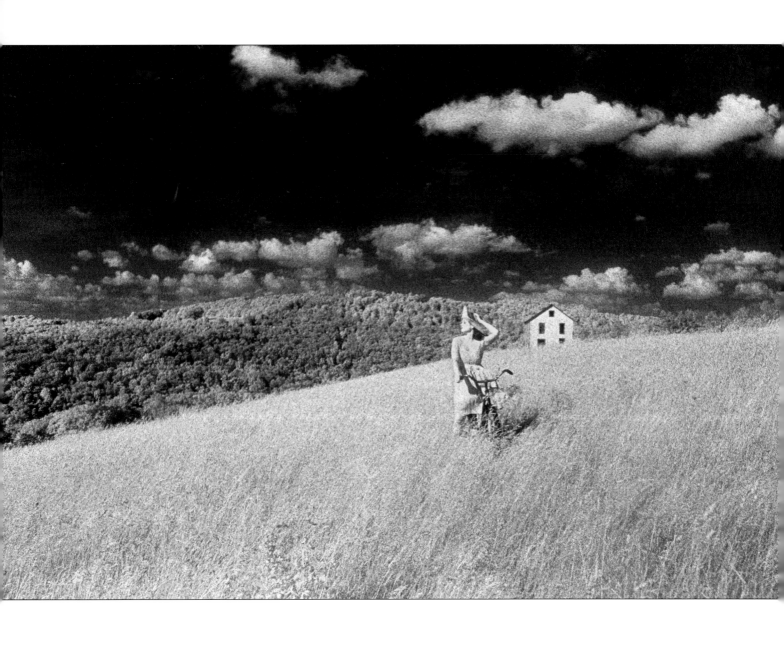

"The infrared, of course, brings out the clouds very nicely."

☐ Importance of Location

This portrait was taken at a favorite spot of mine for infrared photography – at the top of a hill where nice white and puffy clouds can usually be found. The infrared, of course, brings the clouds out very nicely.

☐ Composition

Upon first viewing this photo, the eye comes in from the left side, following the diagonal line of the grass against the dark of the trees on the hill in the distance. The camera angle was chosen to keep the horizon line above her head and the grass line below her shoulders. We also have information occurring at all levels, in the foreground, the middleground and the background. The diagonal of the grass in the foreground points towards Stephanie, the model. The position of the bike in the middle points it towards the bottom right corner. The vertical lines of the house in the background add support, while finally, the far background horizontal line converges with the diagonal line that started at where our eye first came in. It was a windy day, and it was this wind that flipped up the brim of the hat, as well as causing the diagonal slant of the foreground grass. With all the compositional elements heading towards the right, Stephanie's left arm comes up to form a triangle that opposes all the other elements. The title of this photo, "On Holiday," fits the open, peaceful mood of the photograph.

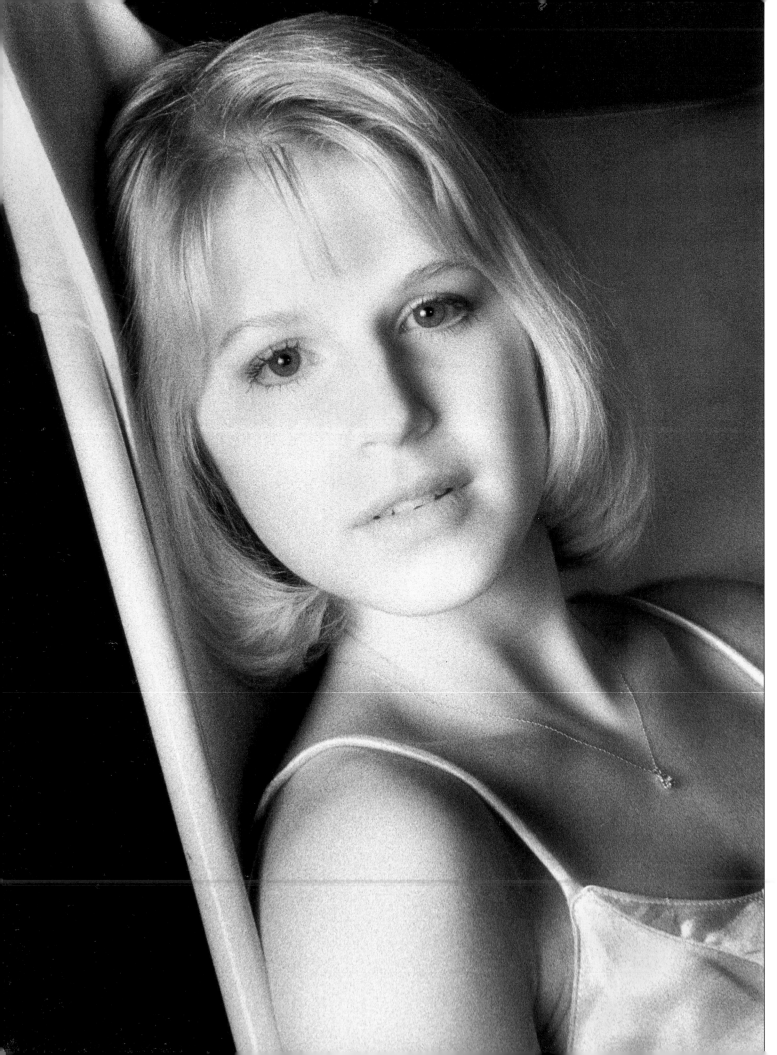

☐ Consider the Options

Black and white infrared images have helped my photography to look different and keep my creativity fresh. When using infrared film for a client, remember that a little goes a long way and it definitely expands the variety of a session. Showing samples is the best way to create interest in having a portrait created using infrared. Not all people appreciate the qualities of infrared, so during a consultation about their session, it can be presented as on option. During the photo session, the question the photographer must keep thinking is, "What would this look like in infrared?" When the unique qualities of infrared coincide with the perfect usage, a successful portrait occurs.

☐ Popular Choice

Prospective clients always enjoy this image when I show them my book of sample photos. When using infrared in the studio with strobe lights, a close up portrait seems to be the most popular among my clients. Here, a medium softbox and reflector were used to create this high school senior portrait. Holly sat in a canvas chair with a red frame. The chair leans back and provides a natural diagonal line. She was also wearing a burgundy prom dress. The quiet expression allows the inner feelings to show.

☐ Eyes and Infrared

When shooting infrared portraits, have the subjects keep their eyes slightly higher than usual, or it will look as though they aren't looking into the lens.

"... have the subjects keep their eyes slightly higher than usual."

☐ Strobe Lighting

If using strobe in the studio works, why not try it on location? A very simple lighting scheme is used in this portrait. A strobe with reflector bowl is bounced off the wall in front of the subject, providing overall illumination, but making it look like the lamp on the table is the only lighting. The shutter speed was slowed in order to pick up some of the ambient light from the lamp. No reflector or fill was necessary, as the room was very small. I was standing out in the hallway while taking the portrait. Keeping the light low enough, yet not getting the area in front overly bright, was the biggest challenge.

☐ Composition

Monica is quite a fine artist, in this case working with pen and ink to create a new piece. Hanging on the wall above her is one of her finished pieces. It helps to explain her style of painting, as well as tying her (compositionally the left side to the right side) to the bed on the right, where more of her art is stacked.

☐ Unposed Portraits

Quite often, and unposed portrait gives a natural feel. This is a perfect example, with Monica taking no direction from me in the posing department. I did adjust several of the props, however, for compositional purposes. The three ink bottles in their triangular pattern was no accident, nor was having all of the brushes leaning towards the light (the spot on her arm, by the way, is a tattoo).

"Quite often, an unposed portrait gives a natural feel."

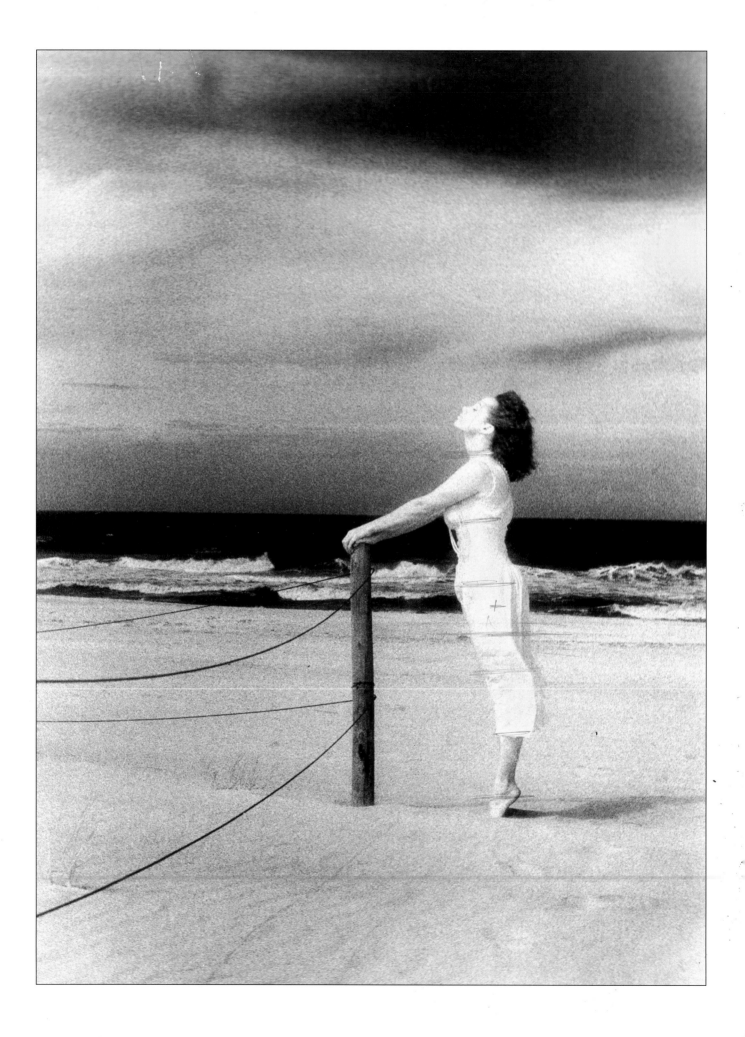

□ Lack of Foliage

So what happens when you use infrared outdoors where there is no foliage that changes into neat tones? I decided to try infrared at the beach.

□ Lines

All we see here is sand, water and sky, with the fence that acts as a leading line to our subject. The neat grainy quality of the film enhances the sand and the clouds. The ocean reflects the blue of the sky and photographs black in all areas except where the breakers crash. The straight vertical line of the model's pose mimics the fence post, and the straight diagonal line of her arms leads us from the post to her upturned face. After watching where the waves were breaking, the camera angle was adjusted so there would be a strip of black between the breakers and the sand. This also put the horizon line at her bustline, so it wouldn't distract from her upper body language. The wind added the finishing touches of blowing the dress and hair about.

".. what happens when you use infrared outdoors where there is no foliage..."

Ideas from Props

☐ Story Behind Image

The beginning of the photograph evolved from the blouse. It had an old fashioned, country look to it and when coordinated with the ragged edged shorts, it gave Tia a quaint summer look. I posed her with the antique piece of farm machinery (a hay tedder) to give the photo its overall aged country look.

☐ Circles and Diagonals

Circles play an important part in this photo. The wheel (a circle) leads us into her pose. The holes of the seat show up quite dark against the light grass area in the background and her sunglasses (this time the sunglasses staying black, although this is never a guarantee) are also circular. Some diagonal rods on the machine inspired the diagonal pose of her hand on her waist.

> "Circles play an important part in this photo."

☐ Processing

If you know how to process and print standard black and white films, infrared should not be a problem for you. A trial run with an unexposed infrared will let you know if your film processing tanks are infrared proof. If the film comes out clear, you have a good tank. I process most of my infrared using Kodak D-76 at 70 degrees for thirteen minutes. Using both Kodak and Konica developing recommendations for developers, temperatures and times should give you a good starting point. The infrared negative can be printed on all types of black and white papers as well as color papers. A top-of-paper screen can also be used to enhance the artistic qualities of the image both in traditional black and white and in color prints. The image was processed in D-19 which gives more contrast and enhances he image.

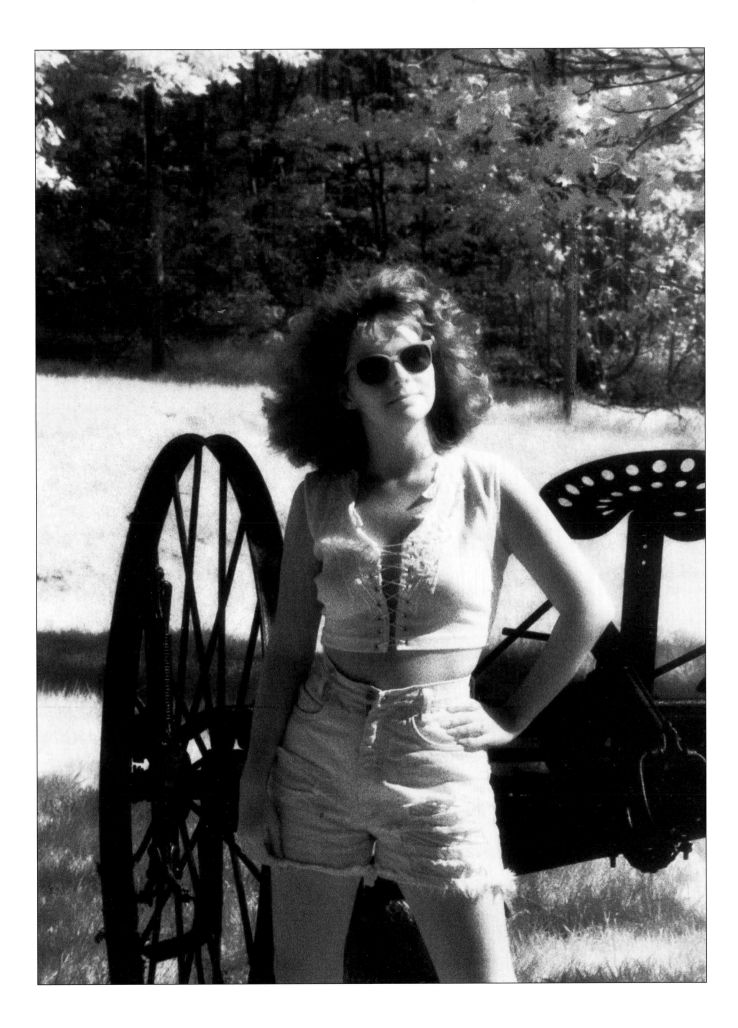

☐ Bridal Portrait

This is a bridal portrait with a unique flair. The first unique element is the veil. After climbing up to the top of this rocky area in casual clothing, the bride changed into her wedding dress. I noticed the wind was fairly strong and when she put on her headpiece, I told her to be sure that it was securely attached in her hair. When placed into her pose, the wind came along and blew the six-foot veil almost straight up into the air. I was able to get three good frames. You have to be ready for almost anything when shooting. The placement of her arms was necessary so she could balance herself. Sunglasses were used so she could look towards the sun without discomfort. With the strong cross light coming over her dress, it brought out the gorgeous detailing. This portrait was done after the wedding so in case the dress was soiled it wouldn't be a big deal. Here is a great example of how a blue sky goes very dark (in this case black) using infrared film.

☐ Suitability of Infrared

Infrared film can be used in all types of portrait situations. The environmental pictorial style of portrait seems to be the most common. While photographing brides, children, couples, families, glamour, high school seniors or weddings, infrared is an automatic artistic tool. On many occasions when the lighting quality is not what is considered good portrait lighting (such as midday) I'll switch to infrared film to create a unique artistic portrait. Window lighting is one of my favorite light sources and after having pleasing results there, I was inspired to photograph using studio strobes and tungsten lights as the light source. Today, I find myself using infrared frequently, even when most other photographers wouldn't.

'You have to be ready for almost anything when shooting.'

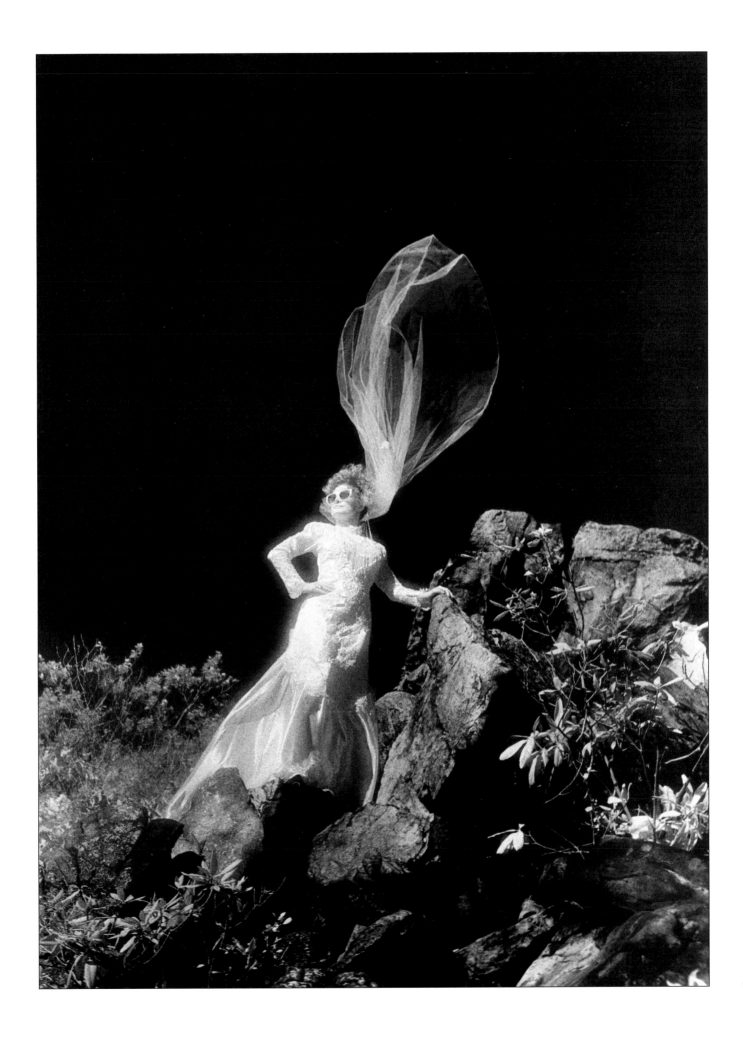

About the Author

Telling stories, creating emotions and planning pleasing compositions are all an integral part of photography. Richard Beitzel believes in these principles and has dedicated his life to the craft. His journey began at the Antonelli Institute of Art and Photography, Philadelphia Campus, where he was first introduced to infrared photography. Upon graduation in 1984, he and his wife, Esther, purchased an existing photography business (now know as Beitzel Photography) in southwestern Pennsylvania.

Richard is a current member of the Professional Photographers of America (PP of A), the American Society of Photographers, the Professional Photographers of Pennsylvania (PP of PA), the Triangle Photographers Association and the Professional Photographers of Mexico. From the PP of A, he received his Certified Professional Photographer status in 1989, his Master of Photography Degree in 1992, and his Craftsman Degree in 1996. He is also a PP of A Affiliated Print Juror. His prints have won various awards, including the Loan Collection, Epcot Exhibition and the International Photography Hall of Fame. He has also won many state and regional print awards for his work and was chosen as the Photographer of the Year by the PP of PA in 1996.

Rich has lectured both internationally and throughout the United States. He also conducts classes and workshops at his studio. For more information, check out his web site at <www.beitzelphotography.com> or <www.photobackgrounds.com>.

Rich's subject matter includes everything from great-grandma to the family dog. He is also recognized for his glamour, boudoir and commercial work. Rich is a favorite among his fellow photographers who can both recognize and appreciate the dedication involved in reaching a certain level of photographic excellence. And let's not forget his clients – all of whom (even the animals) appreciate his sense of humor and dis-

tinctive style. With the love of his craft, his family and his friends, Richard Beitzel's photographic journey continues – enjoy the trip!

© Simone Portraitistes, 1998.

Index

Other Books from
Amherst Media, Inc.

Build Your Own Home Darkroom

Lista Duren & Will McDonald

This classic book teaches you how to build a high quality, inexpensive darkroom in your basement, spare room, or almost anywhere. Includes valuable information on: darkroom design, woodworking, tools, and more! $17.95 list, 8½x11, 160p, order no. 1092.

Wedding Photographer's Handbook

Robert and Sheila Hurth

A complete step-by-step guide to succeeding in the world of wedding photography. Packed with shooting tips, equipment lists, must-get photo lists, business strategies, and much more! $24.95 list, 8½x11, 176p, index, b&w and color photos, diagrams, order no. 1485.

Outdoor and Location Portrait Photography

Jeff Smith

Learn how to work with natural light, select locations, and make clients look their best. Step-by-step discussions and helpful illustrations teach you the techniques you need to shoot outdoor portraits like a pro! $29.95 list, 8½x11, 128p, b&w and color photos, index, order no. 1632.

Freelance Photographer's Handbook

Cliff & Nancy Hollenbeck

Whether you want to be a freelance photographer or are looking for tips to improve your current freelance business, this volume is packed with ideas for creating and maintaining a successful freelance business. $29.95 list, 8½x11, 107p, 100 b&w and color photos, index, glossary, order no. 1633.

Infrared Landscape Photography

Todd Damiano

Landscapes shot with infrared can become breathtaking and ghostly images. The author analyzes over fifty of his most compelling photographs to teach you the techniques you need to capture landscapes with infrared. $29.95 list, 8½x11, 120p, b&w photos, index, order no. 1636.

Wedding Photography:
Creative Techniques for Lighting and Posing

Rick Ferro

Creative techniques for lighting and posing wedding portraits that will set your work apart from the competition. Covers every phase of wedding photography. $29.95 list, 8½x11, 128p, b&w and color photos, index, order no. 1649.

Professional Secrets of Advertising Photography

Paul Markow

No-nonsense information for those interested in the business of advertising photography. Includes: how to catch the attention of art directors, make the best bid, and produce the high-quality images your clients demand. $29.95 list, 8½x11, 128p, 80 photos, index, order no. 1638.

Lighting Techniques for Photographers

Norm Kerr

This book teaches you to predict the effects of light in the final image. It covers the interplay of light qualities, as well as color compensation and manipulation of light and shadow. $29.95 list, 8½x11, 120p, 150+ color and b&w photos, index, order no. 1564.

Infrared Photography Handbook

Laurie White

Covers black and white infrared photography: focus, lenses, film loading, film speed rating, batch testing, paper stocks, and filters. Black & white photos illustrate how IR film reacts. $29.95 list, 8½x11, 104p, 50 b&w photos, charts & diagrams, order no. 1419.

How to Operate a Successful Photo Portrait Studio

John Giolas

Combines photographic techniques with practical business information to create a complete guide book for anyone interested in developing a portrait photography business (or improving an existing business). $29.95 list, 8½x11, 120p, 120 photos, index, order no. 1579.

Computer Photography Handbook

Rob Sheppard

Learn to make the most of your photographs using computer technology! From creating images with digital cameras, to scanning prints and negatives, to manipulating images, you'll learn all the basics of digital imaging. $29.95 list, 8½x11, 128p, 150+ photos, index, order no. 1560.

Achieving the Ultimate Image

Ernst Wildi

Ernst Wildi teaches the techniques required to take world class, technically flawless photos. Features: exposure, metering, the Zone System, composition, evaluating an image, and more! $29.95 list, 8½x11, 128p, 120 b&w and color photos, index, order no. 1628.

Black & White Portrait Photography

Helen Boursier

Make money with b&w portrait photography. Learn from top b&w shooters! Studio and location techniques, with tips on preparing your subjects, selecting settings and wardrobe, lab techniques, and more! $29.95 list, 8½x11, 128p, 130+ photos, index, order no. 1626

Profitable Portrait Photography

Roger Berg

A step-by-step guide to making money in portrait photography. Combines information on portrait photography with detailed business plans to form a comprehensive manual for starting or improving your business. $29.95 list, 8½x11, 104p, 100 photos, index, order no. 1570

Professional Secrets for Photographing Children

Douglas Allen Box

Covers every aspect of photographing children on location and in the studio. Prepare children and parents for the shoot, select the right clothes capture a child's personality, and shoot story book themes. $29.95 list, 8½x11, 128p, 74 photos, index, order no. 1635.

Handcoloring Photographs Step-by-Step

Sandra Laird & Carey Chambers

Learn to handcolor photographs step-by-step with the new standard in handcoloring reference books. Covers a variety of coloring media and techniques with plenty of colorful photographic examples. $29.95 list, 8½x11, 112p, 100+ color and b&w photos, order no. 1543.

Special Effects Photography Handbook

Elinor Stecker Orel

Create magic on film with special effects! Little or no additional equipment required, use things you probably have around the house. Step-by-step instructions guide you through each effect. $29.95 list, 8½x11, 112p, 80+ color and b&w photos, index, glossary, order no. 1614.

Fine Art Portrait Photography

Oscar Lozoya

The author examines a selection of his best photographs, and provides detailed technical information about how he created each. Lighting diagrams accompany each photograph. $29.95 list, 8½x11, 128p, 58 photos, index, order no. 1630.

Family Portrait Photography

Helen Boursier

Learn from professionals how to operate a successful portrait studio. Includes: marketing family portraits, advertising, working with clients, posing, lighting, and selection of equipment. Includes images from a variety of top portrait shooters. $29.95 list, 8½x11, 120p, 123 photos, index, order no. 1629.

The Art of Infrared Photography, *4th Edition*

Joe Paduano

A practical guide to the art of infrared photography. Tells what to expect and how to control results. Includes: anticipating effects, color infrared, digital infrared, using filters, focusing, developing, printing, handcoloring, toning, and more! $29.95 list, 8½x11, 112p, order no. 1052

The Art of Portrait Photography

Michael Grecco

Michael Grecco reveals the secrets behind his dramatic portraits which have appeared in magazines such as *Rolling Stone* and *Entertainment Weekly*. Includes: lighting, posing, creative development, and more! $29.95 list, 8½x11, 128p, order no. 1651.

Essential Skills for Nature Photography

Cub Kahn

Learn all the skills you need to capture landscapes, animals, flowers and the entire natural world on film. Includes: selecting equipment, choosing locations, evaluating compositions, filters, and much more! $29.95 list, 8½x11, 128p, order no. 1652.

Photographer's Guide to Polaroid Transfer

Christopher Grey

Step-by-step instructions make it easy to master Polaroid transfer and emulsion lift-off techniques and add new dimensions to your photographic imaging. Fully illustrated every step of the way to ensure good results the very first time! $29.95 list, 8½x11, 128p, order no. 1653.

Wedding Photojournalism

Andy Marcus

Learn the art of creating dramatic unposed wedding portraits. Working through the wedding from start to finish you'll learn where to be, what to look for and how to capture it on film. A hot technique for contemporary wedding albums! $29.95 list, 8½x11, 128p, order no. 1656.

Studio Portrait Photography of Children and Babies

Marilyn Sholin

Learn to work with the youngest portrait clients to create images that will be treasured for years to come. Includes tips for working with kids at every developmental stage, from infant to pre-schooler. Features: lighting, posing and much more! $29.95 list, 8½x11, 128p, order no. 1657.

Professional Secrets of Wedding Photography

Douglas Allen Box

Fifty top-quality portraits are individually analyzed to teach you the art of professional wedding portraiture. Lighting diagrams, posing info and technical specs are included for every image. $29.95 list, 8½x11, 128p, order no. 1658.

Photographer's Guide to Shooting Model & Actor Portfolios

CJ Elfont, Edna Elfont and Alan Lowry

Create outstanding images for actors and models looking for work in fashion, theater, television, or the big screen. Includes the business, photo and professional information you need to succeed! $29.95 list, 8½x11, 128p, order no. 1659.

Photo Retouching with Adobe Photoshop

Gwen Lute

Designed for photographers, this manual teaches every phase of the process, from scanning to final output. Learn to restore damaged photos, correct imperfections, create realistic composite images and correct for dazzling color. $29.95 list, 8½x11, 128p, order no. 1660.

Storytelling Wedding Photography

Barbara Box

Barbara and her husband shoot as a team at weddings. Here, she shows you how to create outstanding candids (which are her specialty), and combine them with formal portraits (her husband's specialty) to create a unique wedding album. $29.95 list, 8½x11, 128p, order no. 1667.

Fine Art Children's Photography

Doris Carol Doyle

Learn to create fine art portraits of children in black & white. Included is information on: posing, lighting for studio portraits, shooting on location, clothing selection, working with kids and parents, and much more! $29.95 list, 8½x11, 128p, order no. 1668.

Black & White Photography for 35mm

Richard Mizdal

A guide to shooting and darkroom techniques! Perfect for beginning or intermediate photographers who wants to improve their skills. Features helpful illustrations and exercises to make every concept clear and easy to follow. $29.95 list, 8½x11, 128p, order no. 1670.